Taxcafe.co.uk Tax Guides

The Company Tax Changes

and How to Plan for Them

By Carl Bayley BSc FCA

Important Legal Notices:

Taxcafe®
Tax Guide: "The Company Tax Changes - and How to Plan for Them"

Published by:
Taxcafe UK Limited
67 Milton Road
Kirkcaldy KY1 1TL
Email: team@taxcafe.co.uk

ISBN 978-1-911020-75-2

Third edition, November 2022

Disclaimer
Before reading or relying on the content of this tax guide please read the disclaimer.

Disclaimer

1. This guide is intended as **general guidance** only and does NOT constitute accountancy, tax, investment or other professional advice.

2. The author and Taxcafe UK Limited make no representations or warranties with respect to the accuracy or completeness of this publication and cannot accept any responsibility or liability for any loss or risk, personal or otherwise, which may arise, directly or indirectly, from reliance on information contained in this publication.

3. Please note that tax legislation, the law and practices of Government and regulatory authorities (e.g. HM Revenue & Customs) are constantly changing. We therefore recommend that for accountancy, tax, investment or other professional advice, you consult a suitably qualified accountant, tax adviser, financial adviser, or other professional adviser.

4. Please also note that your personal circumstances may vary from the general examples provided in this guide and your professional adviser will be able to provide specific advice based on your personal circumstances.

5. This guide covers UK taxation only and any references to 'tax' or 'taxation', unless the contrary is expressly stated, refer to UK taxation only. Please note that references to the 'UK' do not include the Channel Islands or the Isle of Man. Foreign tax implications are beyond the scope of this guide.

6. All persons described in the examples in this guide are entirely fictional. Any similarities to actual persons, living or dead, or to fictional characters created by any other author, are entirely coincidental.

7. The views expressed in this publication are the author's own personal views and do not necessarily reflect the views of any organisation he may represent.

About the Author

Carl Bayley is the author of a series of 'Plain English' tax guides designed specifically for the layman and the non-specialist. His aim is to help business owners and families understand the taxes they face and make savings through sensible planning and by having confidence to know what they can claim. Carl's speciality is his ability to take the weird, complex world of taxation and set it out in the kind of clear, straightforward language taxpayers can understand. As he often says, "My job is to translate 'tax' into English."

Carl enjoys his role as a tax author, as he explains, "Writing these guides gives me the opportunity to use the skills and knowledge learned over more than thirty years in the tax profession for the benefit of a wider audience. The most satisfying part of my success as an author is the chance to give the average person the same standard of information as the 'big guys' at a price everyone can afford."

Carl takes the same approach when speaking on taxation, a role he undertakes with great enthusiasm, including his highly acclaimed annual 'Budget Breakfast' for the Institute of Chartered Accountants. In addition to being a recognised author and speaker, Carl has spoken on taxation on radio and television, including the BBC's 'It's Your Money' programme and BBC Radio 2's Jeremy Vine Show.

Carl began his career as a Chartered Accountant in 1983 with one of the 'Big 4' accountancy firms. After qualifying as a double prize-winner, he began specialising in taxation. He worked for several major international firms until beginning the new millennium by launching his own practice, through which he provided advice on a wide variety of taxation issues for twenty years, before deciding to focus exclusively on his favourite role as author and presenter.

Carl is a former Chairman of the Tax Faculty of the Institute of Chartered Accountants in England and Wales and a member of the Institute's governing Council. He is also a former President of ICAEW Scotland and member of the ICAEW Board. He has co-organised the annual Practical Tax Conference since its inception in 2002.

Aside from his tax books, Carl is an avid creative writer. He is currently waiting for someone to have the wisdom to publish his debut novel, while he works on the rest of the series. When he isn't working, he takes on the equally taxing challenges of hill walking and horse riding: his Munro tally is now 106 and, while he remains a novice rider, his progress is cantering along nicely. Carl lives in the Scottish Borders, where he enjoys spending time with his partner, Linda. He has three children and his first grandchild arrived in April 2021.

Dedication & Thanks

For the Past,

To Diana, the memory of your love warms me still. Thank you for bringing me into the light and making it all possible. To Arthur, your wise words still come back to guide me; and to my loving grandmothers, Doris and Winifred. Between you, you left me with nothing I could spend, but everything I need.

Also to my beloved friends: Mac, William, Edward, Rusty, Dawson, and the grand old lady, Morgan. Thank you for all those happy miles; I still miss you all.

For the Present,

To the lovely lady Linda, one of the front line heroes of the past two years. Bless you, my princess; I'm so proud of you. Thank you for bringing the sunshine back into my life, for opening my ears, and putting the song back into my heart. How quickly and completely you have become my world: I owe you more than you will ever know.

Also to Ollie, the world's oldest puppy: thank you for these happy miles.

For the Future,

To James, a true twenty-first century gentleman and one of the nicest guys I have ever met. To Robert, the 'chip off the old block', who is both cursed and blessed to have inherited a lot of my character; luckily for him, there is a lot of his mother in him too! And to Michelle, one of the most interesting people I have ever met. I am so very proud of every one of you and I can only hope I, in turn, will be able to leave each of you with everything you need.

Finally, to Sebastian: welcome to the world, wee man.

Thanks

Thanks to the Taxcafe team, past and present, for their help in making these books more successful than I could ever have dreamed.

I would like to thank my old friend and mentor, Peter Rayney, for his inspiration and for showing me tax and humour can mix. Thanks also to Rebecca, Paul and David for taking me into the 'fold' at the Tax Faculty and for their fantastic support at our Practical Tax Conference over many years.

And last, but far from least, thanks to Nick for giving me the push!

C.B., Roxburghshire, November 2022

Contents

Introduction

The UK Budgets and Financial Statements in 2021 and 2022 included a huge raft of changes to the Corporation Tax regime, as well as confirming other changes already announced that are particularly relevant to companies. Despite Kwasi Kwarteng's attempt to reverse some of the measures in his notorious September 2022 'Mini Budget', most of those changes are still with us and are already having a major impact on company taxation in the UK.

The changes are so wide-ranging and fundamental that we at Taxcafe decided we should publish a guide to help company owners, their accountants, and advisers, understand the impact of the changes on their companies, the tax planning opportunities available, and some of the pitfalls to be wary of.

In the long run, many companies will inevitably see increases in their Corporation Tax bills. But we will explore a range of options to mitigate the impact of those increases. We will also see that, in the short term, there are many opportunities to make additional Corporation Tax savings, both in terms of cashflow, and long-term absolute savings.

While some of the Corporation Tax changes do not affect all companies, taken as a package, the changes are relevant to every company: large, medium-sized, or small; profitable or loss-making; whether carrying on a trade, investing in and letting property, or some of both.

While we will, of course, primarily focus on the costs and benefits of the tax changes, we will never lose sight of the bigger picture where tax savings must be weighed against the commercial impact of the company's actions.

In Chapter 1, we will begin by looking at some of the background to the Corporation Tax increases coming into force in April 2023 (although they are already affecting some companies), as well as providing a brief summary of how Corporation Tax works to help you get the most out of the rest of the guide.

Chapter 2 deals with the Corporation Tax increases and looks at many of the extra complexities involved, including transitional rules for accounting periods spanning the changes on 1st April

2023 and the definition, and impact of, associated companies. We will see that having an additional associated company will sometimes have a tax cost, but could also sometimes save tax; or it may make no difference at all. We look at what the costs and benefits are, how to avoid those costs, and whether, commercially, the action needed to save tax is justified.

Chapter 3 looks at marginal rate tax planning. Generally speaking, this is all about timing. With many companies' Corporation Tax rates set to increase next year, the timing of deductible expenditure, taxable income, and capital gains on property disposals, can make a big difference to the company's tax bill. Of course, the timing of a lot of income and expenditure cannot be altered, or it would not make commercial sense to do so, but there are also many items that are worth considering and we cover the main ones in this chapter.

In Chapter 4 we look at the extraordinary opportunity presented by the 130% 'super-deduction': where companies can deduct up to 130% of their expenditure on items like new trucks and vans, machinery, furniture, and computer equipment, from their taxable profits. However, while the super-deduction presents excellent tax-saving opportunities for some companies, there are also many instances where it will be better for the company to wait until a later accounting period when they may enjoy even greater tax savings on their expenditure. The commercial reality of some of the super-deduction's limitations is also examined with a crucial focus on after tax cost rather than how much tax is saved.

Chapter 4 also covers other important changes to tax relief for companies on its asset purchases, including expenditure on fixtures and fittings, and cars (both electric and conventional); as well as other items not qualifying for the super-deduction. We look at how all the changes fit in with the rest of the capital allowances regime, and how companies can get the best tax relief for their capital expenditure under any circumstances.

In Chapter 5, we look at the temporary extension to the rules that allow companies to carry trading losses back to earlier accounting periods to obtain Corporation Tax relief. This extension could allow some large companies to claim additional tax refunds of up to £760,000. Smaller companies will benefit too, with a speedier, 'stand alone' claim process that could quickly bring in extra tax refunds of up to £76,000.

Quick refunds will be invaluable to many companies struggling in the current economic climate, but for those that expect to bounce back there are some tricky choices to be made. We look at the options available and the factors to be considered.

Finally, in Chapter 6, we examine the issue of 'salary versus dividends', and look at what the Corporation Tax changes, as well as the increases in dividend taxation, and numerous changes to the National Insurance regime, mean for company owners wishing to extract funds from their company as tax efficiently as possible. This complex subject never seems to get any simpler, but we consider all the issues to be addressed and look at most of the likely combinations you will encounter. Despite the topic's complexity, we also summarise our findings as simply as possible.

You will find many opportunities to mitigate the impact of the forthcoming Corporation Tax increases, and to make additional savings in the meantime, detailed in this guide.

Whatever the broader economic situation may be, company owners have every right to protect themselves, their business, their company, and their family. Saving tax through sensible planning measures is part of that: and that's exactly what this guide will help you do.

Scope of this Guide

This guide covers UK tax issues for UK resident companies and their owners only.

With the exception of Chapter 5, the principles explained in the majority of this guide apply equally to both trading companies and property investment companies. Where differences do arise, they are pointed out in the text.

The reader must bear in mind the general nature of this guide. Individual circumstances vary and the tax implications of an individual, company, or other entity's actions will vary with them. For this reason, it is always vital to get professional advice before undertaking any tax planning or other transactions that may have tax implications. The author and Taxcafe UK Limited cannot accept any responsibility for any loss that may arise as a consequence of any action taken, or any decision to refrain from action taken, as a result of reading this guide.

About the Examples

All persons described in the examples in this guide are entirely fictional characters created specifically for the purposes of this guide. Any similarities to actual persons, living or dead, or to fictional characters created by any other author, are entirely coincidental.

Likewise, the companies described in the examples in this guide are similarly fictional corporations created specifically for the purposes of this guide and any similarities to actual companies, past or present, are again entirely coincidental.

Unless expressly stated to the contrary, the companies referred to in the examples in this guide:

i) Are UK resident
ii) Do not have any associated companies (see Section 2.5)
iii) Do not fall within any of the exceptions in Section 2.8

Subject to point (iii), while a particular business activity may be specified for some of the companies in the examples, this is not generally meant to restrict the application of the principles being illustrated. In the case of Chapter 5, however, it is additionally assumed that any losses arising are trading losses.

Terminology

The following terms have the meanings given below throughout this guide:

A **'spouse'** includes a civil partner, but only includes spouses who are legally married (or legally registered civil partners).

A **'tax year'** means the year ending 5th April, which applies to income and capital gains received by individuals and is slightly different to the Financial Year used for Corporation Tax purposes (see Section 1.2).

Chapter 1

Background to the Tax Changes

1.1 WHY THE CORPORATION TAX RATE IS GOING UP

The pandemic had an enormous financial cost. Government spending leaped to unprecedented levels. Much of this was vital to support the UK economy and save lives. Since then, there has been the further impact of the war in Ukraine, leading to soaring energy prices and the highest inflation rates we have seen for decades.

All this inevitably means there is a price to pay and the Government has chosen to place a lot of the burden on companies. Why? The cynic in me says this is because companies don't have a vote. But there are other factors at play. Some of the after tax profits made by the larger companies operating in the UK eventually flow overseas in the form of dividends: a loss to the UK economy.

Our current, low, rate of Corporation Tax (19%) is attractive and highly competitive internationally. But every country in the world is facing its own financial crisis, so company tax rates may increase elsewhere too: although there is little evidence of this so far, apart from President Biden's as yet unfulfilled pledge to increase the US Federal Corporate Income Tax rate from 21% to 28%.

Perhaps our Government is gambling we can increase our Corporation Tax rates and yet still remain competitive. This idea may be supported by the Organisation for Economic Co-operation and Development ('OECD') plan to impose a global minimum corporate tax rate of 15%: although there is still a big difference between 15% and our future main rate of 25%.

The Government may be thinking targeting companies instead of individuals will not reduce the amount of money flowing through the UK economy. But, aside from the obvious fact that company owners will have less after tax profits to pay themselves from, lower after tax profits in companies also mean less money left to invest, less money left to pay suppliers, less money left to pay employees, and higher prices charged to customers to compensate.

It may not hit us in the pocket as directly or as obviously as Income Tax, but Corporation Tax affects us all.

Such a large hike in Corporation Tax rates seems rather out of character for a Conservative Government. Indeed, previous Conservative Chancellors have pointed to the fact economic studies suggest lower Corporation Tax rates will actually produce greater tax yields in the long run (as they stimulate investment and attract business into the UK). This was certainly the philosophy Kwasi Kwarteng was subscribing to when he proposed to scrap the planned Corporation Tax increase. But market reaction forced him out of a job and the increase was swiftly reinstated. In short, after a period of unprecedented fiscal turmoil, the Corporation Tax increase *is* now going ahead, with its main architect now installed in Number 10.

These are exceptional times calling for exceptional measures. Government forecasts suggest the Corporation Tax increase will raise around £16 to £17 billion per year. Unfortunately, given that the Government had to borrow around £600 billion extra to fund its coronavirus support package, with at least a further £31 billion needed to fund its Energy Price Guarantee this winter, the extra Corporation Tax revenue is just a drop in the ocean. There will need to be a lot more tax rises to make any serious impact on the national debt.

The Government may be pinning its hopes on good old stealth taxation. At current inflation rates, the freeze in Income Tax bands and thresholds now looks set to rake in the cash big time at the Treasury. Alternatively, it may be after the next General Election that we get the *really* bad news. After all, our multi-trillion pound debt is only going to reach 97% of GDP before then.

But these telephone number size figures are for the politicians to worry about. On a national level, I hope the Government's gamble pays off. For ourselves, we just have to plan for the changes as they affect our own companies: and that's what this guide is all about.

1.2 INTRODUCTION TO CORPORATION TAX

All of a company's profits, income and capital gains for an accounting period are added together and treated as a single total sum of 'profits chargeable to Corporation Tax'. You will occasionally see this important phrase appear in later sections, although I will more often simply refer to a company's 'profit' for an accounting period. In either case, I mean the company's total taxable income, profits, and capital gains for that period.

With the exception of dividend income, the same tax is paid on all types of income or gains received by the company, and at the same rate. However, as we shall see in the following chapters, the rate of Corporation Tax paid by the company is dependent on a number of factors, including the date its accounting period begins and ends and the total level of its profits and gains from all sources.

Companies are generally exempt from Corporation Tax on dividend income received; although dividends received in accounting periods ending after 31st March 2023 may create an additional tax cost in some cases (see Section 2.10).

Financial Years

Corporation Tax operates by reference to 'Financial Years'. Just to make life even more confusing than it already undoubtedly is, the Financial Year is slightly different to the tax year ending on 5th April that applies to income received by individuals.

A Financial Year is the year ending on 31st March in any calendar year, but is officially described by reference to the calendar year in which it began. Hence, for example, the 2022 Financial Year is the year commencing 1st April 2022 and ending 31st March 2023. It is important to be aware of this official terminology, as this is what is used on the Corporation Tax Return.

Periods Spanning Two Financial Years

Where your company's accounting period does not end on 31st March, it will generally span two Financial Years. The profits of the accounting period are then split across the two Financial Years on a pro rata basis. A profit of £100,000 for a 12 month accounting period ending 31st December 2022 would be split as follows:

2021 Financial Year: £100,000 x 90/365 £24,658
2022 Financial Year: £100,000 x 275/365 £75,342

Where the Corporation Tax rate is the same in both Financial Years, this split is completely academic. However, where the Corporation Tax rate changes from one Financial Year to the next (as it will in 2023), the split can have a real impact: as we shall see in the next chapter.

Leaping Ahead

To take another example, a profit of £100,000 for a twelve month accounting period ending 31st December 2024 would be split as follows:

2023 Financial Year: £100,000 x 91/366 £24,863
2024 Financial Year: £100,000 x 275/366 £75,137

As we can see, the fact that 2024 is a leap year makes a slight difference to this calculation. Furthermore, it is worth pointing out that the 2023 Financial Year ending on 31st March 2024 will be a 'Leap Financial Year' of 366 days' duration. This will lead to a few minor, but curious, quirks in some company's Corporation Tax calculations, as we shall see later in the guide.

Corporation Tax Payments

For companies with annual profits not exceeding £1.5m, Corporation Tax is currently payable nine months and one day after the end of the accounting period. For example, the Corporation Tax for the year ending 31st March 2023 is due by 1st January 2024.

Larger companies must pay Corporation Tax in quarterly instalments and the Government has consulted on the possibility of extending this regime to smaller companies some time after the next General Election.

The £1.5m threshold for quarterly instalments must be divided among any associated companies in a similar way to the lower and upper limits for the small profits rate (see Section 2.4).

1.3 CLOSE COMPANIES

The vast majority of private companies are 'close companies' and this concept is important for a number of tax purposes.

Broadly speaking, a company is a 'close company' if it is under the control of five people or less. This generally arises when any group of five or less individuals, together with other individuals deemed to be 'connected' with them (see Appendix C), own more than 50% of the company's share capital (although control can sometimes arise in other ways). A company where all the shareholders are directors is also a close company.

Chapter 2

The Corporation Tax Increase & What it Means for You

2.1 THE CORPORATION TAX INCREASE

In the March 2021 Budget, former Chancellor Rishi Sunak announced the main rate of Corporation Tax would be increased from the current rate of 19% to a new rate of 25% with effect from 1st April 2023. This is one of the most significant tax increases in recent times, adding almost a third to many companies' tax bills.

The current rate of 19% will remain in place until 31st March 2023 although, as we shall see in Section 2.7, some companies have already begun to see increases in their overall effective tax rate.

The new 25% rate will not apply to all companies. Companies making annual profits of £50,000 or less will benefit from the 'small profits rate' of 19%, which will also come into effect from 1st April 2023. In other words, companies with annual profits of no more than £50,000 should not suffer any increase in their Corporation Tax liabilities.

Companies with annual profits between £50,000 and £250,000 will also pay a reduced rate of Corporation Tax, somewhere between 19% and 25%. This will be achieved by applying a system of 'marginal relief' to companies with annual profits falling between the 'lower limit' of £50,000 and the 'upper limit' of £250,000.

Marginal relief will be given at a rate of 3/200ths on the amount by which profits are less than the upper limit of £250,000, as illustrated by this example.

Example
Nevis Ltd makes a profit of £180,000 for the year ending 31st March 2024. Its profit is therefore £70,000 less than the upper limit. The company's Corporation Tax bill is calculated as follows:

£180,000 x 25%	£45,000
Less Marginal Relief	
£70,000 x 3/200	(£1,050)
Corporation Tax due	£43,950

In this case, the company's overall effective Corporation Tax rate is 24.417%.

The effective rate given after marginal relief can also be regarded as the average rate, i.e. the average rate of Corporation Tax paid on all the company's profits. Some more average rates for annual company profits arising after 31st March 2023 are given in the table below.

Corporation Tax Payable for Accounting Periods Commencing After 31st March 2023

Annual Profits	Corporation Tax	Average Rate	Increase in Tax
£30,000	£5,700	19.000%	£0
£40,000	£7,600	19.000%	£0
£50,000	£9,500	19.000%	£0
£60,000	£12,150	20.250%	£750
£70,000	£14,800	21.143%	£1,500
£80,000	£17,450	21.813%	£2,250
£90,000	£20,100	22.333%	£3,000
£100,000	£22,750	22.750%	£3,750
£125,000	£29,375	23.500%	£5,625
£150,000	£36,000	24.000%	£7,500
£175,000	£42,625	24.357%	£9,375
£200,000	£49,250	24.625%	£11,250
£225,000	£55,875	24.833%	£13,125
£250,000	£62,500	25.000%	£15,000
£275,000	£68,750	25.000%	£16,500
£300,000	£75,000	25.000%	£18,000

Notes to the Table
i) Profits are for a 12 month accounting period starting after 31· March 2023
ii) The company has no associated companies (see Section 2.5)
iii) The company is not subject to any of the exceptions in Section 2.8

'Increase in Tax' represents the additional Corporation Tax payable on the same level of annual profit compared with the current single rate of 19%.

2.2 SHORT AND LONG ACCOUNTING PERIODS

The lower and upper limits of £50,000 and £250,000 respectively are reduced where the company draws up accounts for a period of less than twelve months. This is done on a pro rata basis, based on the number of days in the accounting period.

Hence, for example, where a company has a nine month accounting period ending on 31st December 2023, the upper limit will be £187,842 (£250,000 x 275/366) and the lower limit will be £37,568 (£50,000 x 275/366).

We use 366 days rather than 365 in these calculations because, as explained in Section 1.2, the nine month period ending 31st December 2023 falls into a 'Leap Financial Year' of 366 days' duration. We will see more leap year quirks later in this chapter.

Where a company draws up accounts for a period of more than twelve months, this is treated as two accounting periods for Corporation Tax purposes: the first twelve months and the remainder.

Trading profits may be divided between the two periods on a pro-rata basis, although a strict 'actual' basis may be used if there is reasonable justification for doing so. Rental income should strictly be allocated on an 'actual' basis, although a pro-rata basis will often be acceptable. Other investment income and capital gains should be allocated to the period in which they arose.

Example
Lawers Ltd is incorporated on 12th May 2023; the company begins trading immediately and draws up its first set of accounts to 30th June 2024, showing a profit of £200,000 for the period of 416 days. Its Corporation Tax calculation is as follows:

1st Accounting Period: Year ending 11th May 2024
Taxable profit is £200,000 x 366/416 = £175,962, which is £74,038 less than the upper limit of £250,000.

£175,962 x 25%	*£43,991*	
Less Marginal Relief		
£74,038 x 3/200	*(£1,111)*	
Corporation Tax due	*£42,880*	*(average rate = 24.37%)*
Payable 12th February 2025		

2nd Accounting Period: 50 Days ending 30th June 2024
Taxable profit is £200,000 x 50/416 = £24,038, which is £10,209 less than the upper limit of £34,247 (£250,000 x 50/365).

£24,038 x 25%	*£6,010*	
Less Marginal Relief		
£10,209 x 3/200	*(£153)*	
Corporation Tax due	*£5,857*	*(average rate = 24.37%)*
Payable 1ˢᵗ April 2025		

As we can see, the average rate for both periods is the same, and is equivalent to the rate applying to a company drawing up accounts for any period of twelve months commencing after 31ˢᵗ March 2023 with a profit of £175,962.

Starting Business
For Corporation Tax purposes, a new accounting period starts when the company starts business. In practice, unlike our example above, this will often be some time after the date of incorporation.

Ceasing Business
An accounting period is also deemed to come to an end for Corporation Tax purposes when the company ceases business.

2.3 MARGINAL CORPORATION TAX RATES

In Section 2.1, we looked at the total Corporation Tax payable by companies on profits arising in accounting periods commencing after 31ˢᵗ March 2023, and the resultant average Corporation Tax rates.

Average tax rates and total tax bills are important for budgeting and cashflow purposes. In tax planning, however, we are far more concerned with marginal tax rates.

A marginal tax rate is the rate of tax suffered on each additional £1 of income or profit or, to look at it another way, the rate of tax saving available on each additional £1 of allowable expenditure.

Governments almost never mention marginal tax rates and politicians seldom seem to understand them: which is a great shame because it is marginal tax rates that so often drive taxpayer behaviour. For example, an employee with a salary of £55,000 and

four children qualifying for child benefit will generally have a marginal tax rate of 76% in the period between November 2022 and March 2023 (combining Income Tax at 40%, National Insurance at 2%, and the Child Benefit Charge). If their boss asks them to work overtime at the weekend to help the company's productivity, what incentive do they have, knowing they will keep less than a quarter of what they earn in return for giving up a weekend with their family?

So, as we can see, marginal tax rates have a very real impact on the economy. And the bad news is that many small companies will be suffering the highest marginal Corporation Tax rate from April 2023 onwards.

As explained in Section 2.1, once a company's profits exceed the lower limit, they are subject to Corporation Tax at the main rate of 25% but also benefit from marginal relief at 3/200ths on the amount by which the company's profits are less than the upper limit.

This means every additional £1 of profit between the lower limit and the upper limit effectively suffers two tax charges: 25p in Corporation Tax and 1.5p in lost marginal relief. Hence, the marginal Corporation Tax rate on profits falling between the lower and upper limits is 26.5%.

So, while the Government will only ever mention the main Corporation Tax rate of 25% and the small profits rate of 19%, there will actually be three marginal Corporation Tax rates applying from April 2023, as follows:

Annual Profits	Marginal Corporation Tax Rate
Up to £50,000	19%
£50,000 to £250,000	26.5%
Over £250,000	25%

These bands apply to a company with no associated companies and for a twelve month accounting period commencing after 31st March 2023.

Let's return to an earlier example to see how the marginal Corporation Tax rate can effectively be used as a 'short cut' to make the Corporation Tax calculation easier.

Example Revisited

Nevis Ltd makes a profit of £180,000 for the year ending 31ˢᵗ March 2024. The company's Corporation Tax bill can be calculated as follows:

First £50,000 @ 19%	*£9,500*
Next £130,000 @ 26.5%	*£34,450*
Total	*£43,950*

As we can see, this simpler calculation produces the same result as we saw in Section 2.1. We will use this simplified method in most cases where marginal relief applies throughout the rest of this guide, although it is always worth remembering it is based on the principles outlined in Section 2.1.

In Chapter 3, we will explore some of the tax planning implications of marginal Corporation Tax rates.

2.4 ASSOCIATED COMPANIES

The lower and upper limits must be reduced where the company has associated companies. This is done by dividing the limits by a factor of one plus the number of associated companies. For example, if the company has four associated companies, the limits are divided by five.

In broad terms, this means, after 31ˢᵗ March 2023, having associated companies will limit your ability to benefit from the small profits rate or marginal relief.

The impact on the upper and lower limits is illustrated by the table below.

Number of Associates	Lower Limit	Upper Limit
0	£50,000	£250,000
1	£25,000	£125,000
2	£16,667	£83,333
3	£12,500	£62,500
4	£10,000	£50,000
5	£8,333	£41,667

Note the above table is based on a twelve month accounting period commencing after 31st March 2023.

Remember, profits below the lower limit are taxed at the small profits rate of 19%, profits above the upper limit are taxed at the main rate of 25%, and profits between the two limits are taxed at an effective marginal rate of 26.5%.

In many cases, the existence of one or more associated companies will lead to an increase in the company's Corporation Tax bill, as illustrated by this table:

Profit:	£25,000	£50,000	£75,000	£100,000
Number Associates	Corporation Tax Payable			
0	£4,750	£9,500	£16,125	£22,750
1	£4,750	£11,375	£18,000	£24,625
2	£5,375	£12,000	£18,625	£25,000
3	£5,688	£12,313	£18,750	£25,000
4	£5,875	£12,500	£18,750	£25,000
5	£6,000	£12,500	£18,750	£25,000

As usual, profits are for a twelve month accounting period commencing after 31st March 2023.

Despite the tax increases shown above, there are also cases where having associated companies will not make any difference to the company's Corporation Tax bill, or will actually prove beneficial. We will look at some of these in Section 2.6. Before that, we need to establish what companies must be counted as associated companies for these purposes.

Note
We will be looking at the impact of associated companies in the next few sections. After that, in the remaining chapters of this guide, unless expressly stated to the contrary, all examples, tables, illustrations, and commentary are based on the assumption that the company has no associated companies. If your company does have associated companies, however, you will need to reduce the £50,000 and £250,000 limits, as they appear throughout the rest of the guide, in accordance with the principles described above.

2.5 WHAT IS AN ASSOCIATED COMPANY?

The basic rule is that two companies are associated with each other if:

- One company is under the control of the other, or
- Both companies are under the control of the same person or persons

In the simplest case, where a company has a single class of shares and a person owns more than 50% of those shares, then that person controls the company.

In other cases, 'control' is assumed to exist where a person, or group of persons, possesses, or is entitled to acquire, rights that entitle them to more than 50% of the company's:

a) Share capital,
b) Voting rights,
c) Distributable income (assuming all available income were distributed), or
d) Assets on a winding up (or in any other circumstances)

It is worth noting deemed control under heading (d) may arise where a person is a loan creditor (i.e. the company owes them money) and their rights as a loan creditor, plus any other rights they hold, entitle them to more than 50% of the company's assets on a winding up. This does not apply where the loan creditor is a bank or other financial institution, but could apply where an individual is owed money by the company.

Control is not confined exclusively to cases falling under headings (a) to (d). Control could also arise where, as a matter of fact, a person has ultimate control over the company.

Some Examples

A: *Pennine Ltd owns all the shares in Cheviot Ltd and 75% of the shares in Kinder Ltd. Pennine Ltd therefore controls both Cheviot Ltd and Kinder Ltd and the three companies are associated.*

B: *Dave owns all the shares in Helvellyn Ltd and 51% of the shares in Striding Ltd. Dave therefore controls both companies and they are associated.*

C: Andrea, Brenda, and Claire each own one third of the shares in Scafell Ltd. Andrea, Brenda, and Diane each own one third of the shares in Snowdon Ltd. Andrea and Brenda together are able to control both Scafell Ltd and Snowdon Ltd and the companies are therefore associated.

Example C demonstrates a key point: where any combination of two or more persons taken together, are able to exercise control over more than one company, those companies are associated.

D: Kristine and Lauren each own 50% of the shares in Macdui Ltd and 50% of the shares in Braeriach Ltd, although Kristine runs Macdui Ltd on a day-to-day basis and Lauren runs Braeriach Ltd. Nonetheless, despite the day to day management of the companies, Kristine and Lauren together are able to control both Macdui Ltd and Braeriach Ltd by virtue of their shareholdings and the companies are therefore associated.

E: Emily, Fiona, and Gabby each own one third of the shares in Malvern Ltd. Emily, Helen, and Maggie each own one third of the shares in Pentland Ltd. The companies are **not** associated: there is no combination of two or more persons that is able to control both companies.

F: John owns 50% of the shares in both Wainwright Ltd and Fells Ltd. The other 50% of Wainwright Ltd is owned by Paul. The other 50% of Fells Ltd is owned by George. On the face of it, the companies do **not** appear to be associated as there is no combination of two or more persons that is able to control both companies.

The position in Example F would be different if both companies' constitutions had some form of 'deadlock' clause whereby John had the casting vote in the event of a dispute between the shareholders. This would mean John was able to exercise control over both companies and they would have to be treated as associated companies for Corporation Tax purposes. It would not matter whether, in practice, John ever used his casting vote, the fact he was entitled to do so would be sufficient to make the companies associated.

Companies with 50/50 shareholdings often pose a difficulty in applying the associated companies rules as, even without the existence of a casting vote, or 'golden share' (sometimes used to produce the same result), there will frequently be a question

hanging over the issue of who, in practice, ultimately controls the company. To avoid the risk of two companies being associated, it may make sense to ensure different persons hold more than 50% of the shares in each company. Naturally, this has commercial implications that need to be considered.

G: Indira owns all the shares in Moruisg Ltd, plus 40% of the shares in Loyal Ltd. Her husband, Romesh, owns the remaining 60% of the shares in Loyal Ltd. In practice, however, Indira exerts ultimate control over Loyal Ltd, as her husband acts in accordance with her instructions. Indira therefore controls both Moruisg Ltd and Loyal Ltd and the companies are associated.

H: Lester owns all the shares in Vorlich Ltd. His wife, Jane, owns all the shares in Stuc Ltd. Jane has also loaned £400,000 to Vorlich Ltd and, under the terms of the loan, she is entitled to 80% of the assets of Vorlich Ltd in the event of a winding up. Jane is therefore deemed to have control of Vorlich Ltd, meaning Vorlich Ltd and Stuc Ltd are associated companies.

I: Everest Holdings Plc has twenty-four subsidiary companies around the world. It holds between 51% and 100% of the shares in each subsidiary. One of those subsidiaries, The Schill Ltd, operates in the Scottish Borders and makes a profit of just £20,000 for the year ending 31st March 2024. However, due to having twenty-four associated companies, The Schill Ltd's upper limit for marginal relief purposes is just £10,000 (£250,000/25) and hence the company must pay Corporation Tax at the main rate of 25%.

Example I demonstrates another key point: overseas associated companies, anywhere in the world, must be counted for the purposes of the small profits rate and marginal relief.

Exceptions

An associated company does not need to be counted for the purposes of the upper and lower limits if it does not carry on any trade or business at any time during the relevant accounting period. This means we can discount dormant companies and companies that merely hold assets passively, with no attempt to carry on any trade or business.

Companies that may be discounted would include a company that only holds cash on deposit, and has no other activities, or a

company that holds a property that is not being rented, developed, or used for any other business purpose. For example, it is quite common to own an overseas holiday home through a company. If the company does not rent out the property, or carry on any other activities, it may be ignored for the purposes of the associated companies rules. The same would be true of a company that held a UK holiday home and did not carry on any other activities, although this would have other tax consequences: see the guide *'Using a Property Company to Save Tax'* for more details.

Where a company's only activity is to hold investments such as stocks and shares, it will be debatable whether it is deemed to be carrying on a business. If the investments are passive, with little or no investment activity carried out, the company may be regarded as inactive, so that it need not be counted for the purposes of the associated companies rules. Where, however, the company is actively trading its investments, a business will exist and the company will need to be included for the purposes of the associated companies rules.

Passive holding companies also do not need to be counted. To be a passive holding company, the company must:

i) Have no assets other than subsidiary companies, in which it holds more than 50% of the shares
ii) Have no income other than dividends
iii) Redistribute all dividends it receives to its own shareholders
iv) Have no chargeable gains (i.e. capital gains)
v) Have no management expenses
vi) Make no charitable donations eligible for Corporation Tax relief

It is possible that Pennine Ltd, in Example A above, might qualify as a passive holding company. This would not prevent is subsidiaries, Cheviot Ltd and Kinder Ltd, from being associated with each other, but it would mean each of them only had to count one associated company for the purposes of the small profits rate and marginal relief, rather than two.

Similarly, Everest Holdings Plc, in Example I, might perhaps be a passive holding company. If so, The Schill Ltd would only have to count twenty-three associated companies, although, in practice, this would make no difference to its Corporation Tax bill unless its annual profits fell below £10,417 (£250,000/24).

No Exception

All associated companies must be counted for the purposes of reducing the upper and lower limits unless they fall into one of the exceptions described above. This includes:

- Overseas companies (as we saw in Example I above)
- Close investment holding companies (see Section 2.8), unless they do not carry on any trade or business during the accounting period, as explained above
- Other companies subject to different rates of Corporation Tax (see Section 2.8)

Spouses, Families and Other Associates

In some cases, the 'associated company' net must be cast even wider. Where there is 'substantial commercial interdependence' between two companies (see below), shares and other rights held by a shareholder's associates must be counted in deciding if the companies are under the control of the same person or persons.

Note, 'associates' for this purpose do not include all the people counted as 'connected persons' for other tax purposes (Appendix C). A person's associates for the associated company rules are:

- Their relatives, as follows:
 - Spouse
 - Parents, grandparents, etc
 - Children, grandchildren, etc
 - Siblings
- Business partners
- A trust where the person or any of their relatives (as above) is, or was, the settlor
- A trust of which the person is a beneficiary
- The estate of a deceased person where the person in question is a beneficiary of the estate

Despite the length of this list, there are many people who are not your associate for Corporation Tax purposes, including your nephews, nieces, aunts, uncles, close friends, father-in-law, mother-in-law, and, most importantly, an unmarried partner. Do not forget, however, that all these people will become your associate if they are also your business partner.

Assuming they are not also a business partner, an unmarried partner is not your associate even if you have children together. However, it is important to remember that your children are an associate of both of you. We will see the significance of this later.

Shares held by an 'associate of an associate' (e.g. your father-in-law) do not need to be counted for the purposes of the associated companies rules. However, it remains important to remember that your associate (e.g. your wife) may need to count shares held by all of their associates (e.g. both you and her father). See Example P below for an illustration of this point.

Substantial Commercial Interdependence

As explained above, where there is substantial commercial interdependence between two companies, shares held by close relatives and certain other associates must be included when looking at the question of whether the same person, or group of persons, controls the companies.

Three types of link may determine whether there is substantial commercial interdependence between two companies. Where any of these links exist, the companies have substantial commercial interdependence. The types of link we need to consider are:

Financial Interdependence
Two companies are financially interdependent if one gives financial support to the other (for example, if one company makes a loan to the other). Companies are also financially interdependent if they both have a financial interest in the affairs of the same business.

Economic Interdependence
Two companies are economically interdependent if they share the same economic objectives, the activities of one benefit the other, or they have common customers.

Organisational Interdependence
Two companies are organisationally interdependent if they have common management, employees, premises, or equipment. Where two people living together each run their own separate company from home, this alone does not amount to substantial commercial interdependence. Provided there are no other links between the companies, they will not be associated.

Associated Companies and Substantial Commercial Interdependence: Summary

Interpreting the above rules in practice may sound like a bit of a headache, but it is important to remember:

- If you, as an individual, control more than one company, those companies are associated: it does not matter if there is substantial commercial interdependence.
- If another company is wholly owned by a person, or persons, who are not your 'associates' (see above), and you have no other links with that company, then it cannot be associated with a company you control: it does not matter if there is substantial commercial interdependence.
- Where there is no substantial commercial interdependence between your company and another company, it does not matter who owns or controls that other company, as long as you cannot control it yourself (alone or together with other persons).

In short, you only need to think about other companies that you, individually (or together with other persons), do not control, where your associates (as defined above) control the company (alone or together with other persons) **AND** there is substantial commercial interdependence.

Examples Revisited

E Revisited: Emily, Fiona, and Gabby each own one third of the shares in Malvern Ltd. Emily, Helen, and Maggie each own one third of the shares in Pentland Ltd. Fiona and Helen are sisters. The companies will be associated if there is substantial commercial interdependence between them since, if this is the case, Fiona and Helen are effectively treated as the same person and, together with Emily, they control both companies.

F Revisited: John owns 50% of the shares in both Wainwright Ltd and Fells Ltd. The other 50% of Wainwright Ltd is owned by John's elder son, Paul. The other 50% of Fells Ltd is owned by John's younger son, George. Although the companies provide slightly different services, they have a common customer base, meaning there is substantial commercial interdependence between them. The companies are therefore associated for Corporation Tax purposes.

Some More Examples

J: Natasha owns all the shares in her software company, Klibreck Ltd; her husband, Ivan, owns all the shares in his garden landscaping company, Slioch Ltd. They each have their own business premises and there are no other links between the companies. The companies are **not** associated for Corporation Tax purposes.

K: Oriel owns 51% of the shares in Cairngorm Ltd, a company specialising in interior design, and 49% of the shares in Lochnagar Ltd, a company set up to run virtual fitness training classes. Oriel's wife, Priti, owns the other 49% of Cairngorm Ltd and 51% of Lochnagar Ltd. Oriel runs Cairngorm Ltd and Priti runs Lochnagar Ltd. Both of them run their company from their shared home but there are no other links between the companies. The companies are **not** associated for Corporation Tax purposes.

L: Suzy owns all the shares in her successful company, Saddleback Ltd. Her husband, Trevor, has just started his own company, Skiddaw Ltd, in which he owns all the shares. Suzy has loaned £250,000 to Skiddaw Ltd, but there are no other links between the companies. Suzy's loan does not entitle her to more than half the assets of Skiddaw Ltd in the event of a winding up (or under any other circumstances). In this scenario, there is no substantial commercial interdependence and the companies are **not** associated for Corporation Tax purposes.

However, the companies **would** be associated if:
a) Under the terms of Suzy's loan, she would be entitled to more than half the assets of Skiddaw Ltd in the event of a winding up. She would then be deemed to control both companies.
b) Saddleback Ltd had made the loan to Skiddaw Ltd.
c) In order to make her loan, Suzy had borrowed money from Saddleback Ltd.
d) In order to make her loan to Skiddaw Ltd, Suzy had borrowed from a bank and had secured her bank loan against Saddleback Ltd's assets.

Under any of (b), (c), or (d), Saddleback Ltd would be providing financial support to Skiddaw Ltd, meaning there was financial interdependence between the companies. However, if Suzy obtained the funds for her loan by taking a dividend out of Saddleback Ltd, this would not create substantial commercial interdependence between the companies and, in the absence of any other links, they would not be associated.

If any of (a) to (d) applied, the companies would cease to be associated at the end of the accounting period in which Skiddaw Ltd repaid the loan (assuming, in the case of (a), that Suzy's entitlement to the assets of Skiddaw Ltd also ceased on repayment of the loan).

M: *Quentin owns all the shares in his interior design company, Dorain Ltd; his wife, Rhona, owns all the shares in Criese Ltd, a company set up to run her antiques business. Quentin often sources antiques through Criese Ltd to use in his interior design projects and Rhona allows him a small discount on her usual prices. The activities of Criese Ltd benefit Dorain Ltd and the companies also have some common customers. There is therefore economic interdependence between the companies and they are associated for Corporation Tax purposes. This would remain the case even if Criese Ltd charged Dorain Ltd and its customers the full market price for the antiques.*

N: *Tina owns Cobbler Ltd, a company that imports shoes from Italy for distribution in the UK. Her mother, Una, owns Uisinis Ltd, which operates a chain of shoe shops. Uisinis Ltd occasionally buys some shoes from Cobbler Ltd, but this is always for the same price, and on the same terms, as other customers. Furthermore, the shoes sourced from Cobbler Ltd only account for a small proportion of Uisinis Ltd's sales. There is an economic relationship between the companies, but it is insufficient to amount to economic interdependence. In the absence of any other links, the companies are **not** associated for Corporation Tax purposes.*

O: *Victoria runs an outdoor clothing shop through her company, Diffwys Ltd. Her father, Victor, owns the adjacent hardware store, which he runs through his company, Rhinog Ltd. Both companies share the same 'back office' area at the rear of the stores and use the same clerical staff for their administration. As the companies share common premises and employees, there is organisational interdependence between them and they are associated for Corporation Tax purposes.*

P: *Walter runs a building company, Schiehallion Ltd. He owns 90% of the shares, his wife, Xena, owns 10%. Xena's father, Grigor, also runs a building company, Glencoe Ltd, and owns all the company's shares. There is economic interdependence between the companies as Schiehallion Ltd often carries out work for Glencoe Ltd as a subcontractor. In fact, it was through Walter's business relationship with Grigor that he met Xena.*

At first glance, it would appear the companies are not associated as Walter controls Schiehallion Ltd; Grigor controls Glencoe Ltd; and the

two men are not associated with each other. (As explained above, shares held by associates of associates are not counted for this purpose.)

However, every shareholder's position must be considered, including Xena's. As there is substantial commercial interdependence between the companies, shares held by her associates are counted. Her husband, Walter, and her father, Grigor, are both her associates, so she is therefore deemed to control both companies and they are associated.

As we can see from Example P, the existence of a minority shareholder effectively brings more associates into play, meaning the company may end up having additional associated companies. A minority shareholder like Xena is effectively a 'linking person' who ends up causing the companies to be associated.

However, case law tells us a person cannot be treated as a 'linking person' in this way if they do not actually own shares in either company. If Xena did not own any shares in either Schiehallion Ltd or Glencoe Ltd, the companies would not be associated.

Married Couples
Examples J, K, and L demonstrate that it is possible for married couples to each run their own company without falling fowl of the 'associated companies' rules. As we saw in Example K, it is even possible for each spouse to have a minority shareholding in the other spouse's company (generally up to 49%).

This means that a married couple can each benefit from the 19% small profits rate on up to £50,000 of company profits. Similar principles apply to other family members.

However, in all cases where different companies are controlled by spouses, close relatives, or other associates (as defined above), it is important to avoid substantial commercial interdependence between the companies and, as we saw in Examples L, M, O, and P, there are many ways of falling into this trap.

Unmarried Couples
As explained above, unmarried couples are not associates for Corporation Tax purposes and hence, where each of them controls their own company, those companies will not usually be associated, even if there is substantial commercial interdependence between them. This will include cases where one partner has a

minority shareholding in the other partner's company (generally up to 49%).

Hence if, in Example L, Suzy and Trevor had been an unmarried couple, the loan could have been structured under any of scenarios (b), (c), or (d), and the companies would still not have been associated for Corporation Tax purposes. (Scenario (a) would have made the companies associated, however.)

Similarly, if Quentin and Rhona (in Example M) had been an unmarried couple, their companies would not have been associated; and, if Victor and Victoria (in Example O) had been an unmarried couple instead of father and daughter, their companies would also not have been associated.

Likewise, if Walter and Xena (in Example P) had been an unmarried couple, the companies would not have been associated. While Xena would still be deemed to control her father's company (due to the substantial commercial interdependence between the companies), Walter would not be her associate, so she could not be deemed to control Schiehallion Ltd.

Hence, in general, an unmarried couple will usually be able to each set up their own company and benefit from the 19% small profits rate on up to £50,000 of company profits in each company: even when the companies have substantial commercial interdependence.

Example Q
Sanjeev and Yvonne are an unmarried couple who have been living together for many years. Yvonne owns all the shares in Bowfell One Ltd, which operates a pub and through which all the wet sales (drinks) are made. Sanjeev owns all the shares in Bowfell Two Ltd, which operates a restaurant within the same building. The companies have common customers, employees, and premises: there can be no doubt there is substantial commercial interdependence. But they are not associated because Sanjeev and Yvonne, being unmarried, are not associates for Corporation Tax purposes.

Hence, the combined operation could make profits of up to £100,000 in total, which would all be taxed at the small profits rate of 19% (on the basis that each company made profits of £50,000).

This is all subject to three very important points:

Firstly, it is important the ultimate control of each company does indeed lie with a different partner. If the position in reality was that one partner actually controlled both companies then they would be associated (see Example G). It is also important to avoid deemed control as a loan creditor (see scenario (a) of Example L).

Secondly, as explained above, if the unmarried couple are also business partners then they will be associates for Corporation Tax purposes and, as far as everything we have discussed in this section is concerned, they would be in the same position as a married couple.

Thirdly, where the couple have one or more children, both of the couple are associates of those children. Hence, if the children own any shares in a company partly owned by one of their parents, they may become a 'linking person' in the same way as Xena in Example P.

Example Q Revisited
Sanjeev and Yvonne have a daughter, Zoe, who helps out in the restaurant run by Bowfell Two Ltd. Sanjeev gives Zoe 10% of the shares in Bowfell Two Ltd. Zoe is associated with both her parents. Hence, because there is substantial commercial interdependence between the two companies, she is deemed to hold all the shares in both companies for the purpose of the associated company rules. The companies are now associated, their upper and lower limits (see Section 2.1) are halved and their combined annual Corporation Tax bills will increase by up to £3,750.

In the next section, I will explain why the extra tax in this example amounts to £3,750.

2.6 COSTS AND BENEFITS OF ASSOCIATED COMPANIES

As we saw in Example Q revisited at the end of the last section, the maximum combined additional cost for two companies of being associated with each other is £3,750. When considering the impact of this cost, it is important to remember that, from 2023 onwards, this is an annual cost: not a mere one-off.

The maximum cost of £3,750 arises because each company has had its lower limit for small profits rate purposes halved, from £50,000 to £25,000. This in turn means an extra £25,000 of profit

in each company is being taxed at the marginal rate of 26.5%, instead of the small profits rate of 19%: an increase of 7.5% in the effective tax rate. The cost for the two companies of being associated is thus £25,000 x 7.5% x 2 = £3,750.

This maximum cost arises when both companies have annual profits anywhere between £50,000 and £125,000, but there remains some cost whenever either company has profits anywhere between £25,001 and £249,999, as illustrated by the table below:

Additional Corporation Tax Arising Where Two Companies are Deemed to be Associated

Profits Co. 1	£30,000	£40,000	£50,000 to £125,000	£150,000
£30,000	£750	£1,500	£2,250	£1,875
£40,000	£1,500	£2,250	£3,000	£2,625
£50,000 to £125,000	£2,250	£3,000	**£3,750**	£3,375
£150,000	£1,875	£2,625	£3,375	£3,000
£175,000	£1,500	£2,250	£3,000	£2,625
£200,000	£1,125	£1,875	£2,625	£2,250
£225,000	£750	£1,500	£2,250	£1,875
£250,000 or more	£375	£1,125	£1,875	£1,500

Profits Co. 1	£175,000	£200,000	£225,000	£250,000 or more
£30,000	£1,500	£1,125	£750	£375
£40,000	£2,250	£1,875	£1,500	£1,125
£50,000 to £125,000	£3,000	£2,625	£2,250	£1,875
£150,000	£2,625	£2,250	£1,875	£1,500
£175,000	£2,250	£1,875	£1,500	£1,125
£200,000	£1,875	£1,500	£1,125	£750
£225,000	£1,500	£1,125	£750	£375
£250,000 or more	£1,125	£750	£375	£0

As usual, profits are for twelve month accounting periods commencing after 31st March 2023.

In Example Q revisited (Section 2.5) the additional Corporation Tax cost arose as a consequence of giving a minority shareholding to an unmarried couple's daughter. In such a situation, it may often make sense to find other ways of rewarding her efforts.

Similar additional Corporation Tax costs will arise in other circumstances, however, such as where two companies owned by people classed as associates (see Section 2.5) have substantial commercial interdependence.

The question then is: do the economic benefits of that substantial commercial interdependence outweigh the additional tax cost. In this context, it is important to remember that, to meet an extra tax cost of £3,750 each year, the companies would need to make an additional £5,102 in combined annual profits between them. This is because the companies will be suffering a marginal Corporation Tax rate of 26.5% (£5,102 less 26.5% equals £3,750).

Let's say, for example, the only reason two companies must be treated as associated companies is that they share the same business premises. Naturally, sharing their business premises gives rise to a saving. If that saving amounts to more than £5,102 per year, it remains worthwhile, despite the additional Corporation Tax cost, but if the annual saving is substantially less than £5,102, it could be worth at least one of the companies looking for different premises.

If companies that would currently be treated as associated companies due to substantial commercial interdependence can arrange their affairs so that the substantial commercial interdependence ceases before the beginning of their first accounting period ending after 31st March 2023, they will not suffer the additional Corporation Tax costs caused by being associated.

Common Control

Where two or more companies are controlled by the same person, or persons, they will always be associated, regardless of whether

there is substantial commercial interdependence, or who owns any minority shareholdings.

There are often good reasons for having more than one company (although I have seen cases where it was simply to satisfy the owner's ego) but, once the Corporation Tax increases come into effect in 2023, it will frequently come at a price. At the very least, you should know what that price is, in order to satisfy yourself it is a cost worth bearing (see Section 2.4 for some examples). In some cases, it will make sense to reduce the number of companies you have, or to refrain from forming new ones.

Naturally, there are many sound, commercial reasons for keeping different businesses, or different parts of a business, in separate companies and these must be considered. In particular, many people with both a trading business and a property letting business like to keep these in separate companies, or are forced to by mortgage lenders. Furthermore, putting a property letting business inside an existing trading company can be disadvantageous for both Capital Gains Tax and Inheritance Tax purposes; although there are also potential advantages if you plan it well (see the Taxcafe.co.uk guides *'Using a Property Company to Save Tax'* and *'How to Save Inheritance Tax'* for more information).

Reducing the number of existing companies you have will involve some form of corporate reorganisation, which may sometimes be a difficult, or costly, exercise. These matters are beyond the scope of this guide, but must be borne in mind. What I will do here, however, is look at the cost, or benefit, of having more than one company in terms of annual Corporation Tax costs alone.

When Does It Matter?

If you already have a company making annual profits between £25,000 and £125,000, forming a second company will do no harm, provided that second company makes annual profits of at least £25,000.

This is because your £50,000 small profits rate band will be divided between your two companies, giving them a lower limit of £25,000 each. As long as both companies fully utilise their reduced small profits rate band of £25,000, nothing is lost.

Example R, Part 1

Caroline has an existing company, Lomond Ltd, that makes an annual profit of £125,000. She is about to start a new venture and is uncertain whether to put her new venture in a separate company. She expects the new venture to yield annual profits of £40,000. If she puts the new venture in her existing company, it will make a total profit of £165,000, giving it a Corporation Tax bill of:

£50,000 x 19%	£9,500
£115,000 x 26.5%	£30,475
Total	£39,975

Alternatively, if she puts the new venture in a separate company, the Corporation Tax bill for her two companies will be as follows:

Lomond Ltd

£125,000 x 25% £31,250
(profits equal reduced upper limit of £125,000)

New Company

£25,000 x 19%	£4,750
£15,000 x 26.5%	£3,975
Total	£8,725

The total tax paid by both companies is £39,975, the same as it would have been if Caroline had put her new venture in her existing company.

The position will be different, however, if the second company does not make sufficient profit to fully utilise its small profits rate band of £25,000.

Example R, Part 2

As it turns out, Caroline's new venture only makes a profit of £10,000 in its first year. If she is using a single company, this will give Lomond Ltd a total profit of £135,000 taxed as follows:

£50,000 x 19%	£9,500
£85,000 x 26.5%	£22,525
Total	£32,025

If she had put the new venture in a separate company, the Corporation Tax bill for her two companies would be as follows:

Lomond Ltd
£125,000 x 25% £31,250
(profits equal reduced upper limit of £125,000)
New Company
£10,000 x 19% £1,900

The total tax paid by both companies is £33,150 or £1,125 more than it would have been if Caroline had put her new venture in her existing company.

In effect, Caroline has wasted £15,000 of her small profits rate band, meaning an extra £15,000 has been taxed at 26.5% instead of 19%: the extra 7.5% tax on £15,000 amounts to £1,125. If the new venture had broken even, the extra tax would have been £1,875, which is the cost of paying 7.5% more on half the lower limit of £50,000 (7.5% x £50,000 x ½ = £1,875).

The same cost (£1,875) would arise if the new venture made a loss and the two companies formed a group (see Section 2.9). However, if the companies were merely associated and not grouped, the loss could not be relieved and the extra cost would be even greater. (Having said that, the risk of losses is one of the main commercial reasons for forming separate companies: although the benefits of loss relief can often still be preserved with a group company)

The same principles effectively apply where you have an existing company making annual profits of less than £25,000 and plan to start a new venture. If the new venture yields profits of more than £25,000, putting it in a separate company will mean you have wasted part of your small profits rate band.

However, if neither your existing company, nor your new venture, ever makes profits of more than £25,000, having a second company will make no difference, as all profits in both companies will be taxed at the small profits rate.

Nonetheless, it is important to be aware that the Corporation Tax rates apply to a company's total taxable income, profits and capital gains. While you may have two companies that you never expect to produce an annual profit of more than £25,000, if one of them has some sort of windfall, such as a capital gain on disposal of a property, for example, you may still suffer an additional cost.

Example S

Nicole has two companies, Benmore Ltd and Binnein Ltd, each of which makes profits of between £15,000 and £20,000 each year and thus pays Corporation Tax at the small profits rate. However, during the year ending 31st December 2025, Benmore Ltd, which is a property investment company, makes a capital gain of £100,000 in addition to its normal rental profits for the year of £20,000, giving it total profits chargeable to Corporation Tax of £120,000. Binnein Ltd's profits for the year are £17,500. The companies' Corporation Tax calculations are as follows:

Benmore Ltd

£25,000 x 19%	*£4,750*
£95,000 x 26.5%	*£25,175*
Total	*£29,925*

Binnein Ltd

£17,500 x 19%	*£3,325*

The total tax paid by both companies is thus £33,250. If Nicole had operated through a single company, it would have had profits chargeable to Corporation Tax of £137,500 and paid Corporation Tax as follows:

£50,000 x 19%	*£9,500*
£87,500 x 26.5%	*£23,188*
Total	*£32,688*

The existence of a second company has cost Nicole an extra £562 in Corporation Tax. While this is not a significant sum, it is something to be aware of.

Note that a capital gain on the sale of trading premises can often be 'rolled over' into the purchase of new trading premises. The same applies to qualifying furnished holiday lets, but I have assumed that was not the case here. See the Taxcafe.co.uk guide *'How to Save Property Tax'* for details.

Benefits of Additional Companies

Where you have an existing company already making annual profits in excess of £125,000, there is actually a potential benefit in forming an additional company.

Example T, Part 1

Tensing has an existing company, Wyvis Ltd, that makes annual profits of £180,000. He is about to expand his operations by opening a new branch and expects this to yield additional annual profits of £60,000. If he includes the new branch within Wyvis Ltd, its annual profit will increase to £240,000, and its Corporation Tax bill will be as follows:

£50,000 x 19%	£9,500
£190,000 x 26.5%	£50,350
Total	£59,850

However, instead of this, Tensing starts a second company, Hope Ltd, to run the new branch. The companies are now taxed as follows:

Wyvis Ltd

£180,000 x 25%	£45,000

(profits exceed reduced upper limit of £125,000)

Hope Ltd

£25,000 x 19%	£4,750
£35,000 x 26.5%	£9,275
Total	£14,025

The total tax paid by the two companies is £59,025, meaning Tensing has made an overall saving of £825 by forming a second company.

To understand how this saving arises, we need to revisit Wyvis Ltd's Corporation Tax calculation (in the second scenario, where it has an associated company), but stick to marginal tax rates, as follows:

£25,000 x 19%	£4,750
£100,000 x 26.5%	£26,500
£55,000 x 25%	£13,750
Total	£45,000

The company's Corporation Tax bill remains unchanged at £45,000, but now we can see how it is made up of the different marginal rates.

As a single company, Wyvis Ltd would have paid Corporation Tax at 19% on £50,000 and 26.5% on £190,000. With two companies, there is still a total of £50,000 being taxed at 19% (£25,000 in each

company); but only £135,000 being taxed at 26.5% (£100,000 in Wyvis Ltd and £35,000 in Hope Ltd). The remaining £55,000 is now taxed at 25%. By setting up a second company, Tensing has changed the tax rate on £55,000 of his profits from 26.5% to 25%, a reduction of 1.5%, leading to his saving of £825 (£55,000 x 1.5% = £825).

Such a strategy is rather risky for such a small potential saving, however. If the new company fails to fully utilise its small profits rate band, there may be an overall cost.

Example T, Part 2
As it transpires, Tensing's new branch only breaks even in its first year of trading, meaning his total annual profits remain £180,000. If he had stuck with a single company, its Corporation Tax bill would have been as follows:

£50,000 x 19%	*£9,500*
£130,000 x 26.5%	*£34,450*
Total	*£43,950*

However, by starting a second company, Wyvis Ltd's Corporation Tax bill has been increased to £45,000 (as we saw in Part 1 above). Hence, forming Hope Ltd has now led to an additional Corporation Tax cost of £1,050.

Tensing has still reduced the tax rate on £55,000 of Wyvis Ltd's profits from 26.5% to 25%, creating a saving of £825, but £25,000 of his small profits rate band has now gone to waste, creating the same cost of £1,875 that we have seen previously. Hence, the net result in this case is an overall cost of £1,050 (£1,875 – £825).

As the existing company's annual profits increase within the bracket from £125,000 to £225,000, the potential saving we saw in Example T, Part 1 increases and the potential overall cost we saw in Part 2 reduces.

Eventually, once the existing company is making annual profits of £225,000, the maximum potential benefit of forming a second company reaches £1,500. This arises because an additional £100,000 of profits in the original company are now taxed at 25% instead of 26.5%. The rate saving of 1.5% equates to £1,500 (£100,000 x 1.5% = £1,500).

Whether it is worth forming a second company for a maximum potential saving at this level is perhaps debatable, although it is worth noting it would take other cost savings of £2,041 for a company with existing profits of £225,000 to achieve the same result.

As usual, the potential saving is reduced if the newly formed second company does not fully utilise its small profits rate band of £25,000. Furthermore, where the existing company has annual profits of less than £250,000, there still remains a risk of creating a small overall increase in Corporation Tax costs (for example, where the existing company has profits of £225,000, the worst case scenario is an overall increase of £375, assuming no unrelieved losses).

Existing Profits of £250,000 or More

Where the existing company has annual profits of at least £250,000, there is effectively nothing to lose since the existing company's profits will be taxed at 25% regardless of how many associated companies it has, while the new company may enjoy the small profits rate on up to £25,000. The maximum potential saving remains £1,500, which is the benefit of having £25,000 taxed at 19% instead of 25%, a rate saving of 6% (£25,000 x 6% = £1,500).

[Alternatively, we can still think of the maximum potential saving arising due to £100,000 of additional profit in the original company being taxed at 25% instead of 26.5%: it comes to the same result.]

Achieving the maximum potential saving of £1,500 remains difficult, however. It requires the second company to make a profit of exactly £25,000. If the new company's profit is any less, part of the small profits rate band is wasted, reducing the overall saving by 6% of the shortfall; if the new company's profit is any more, the total amount of profit taxed at 26.5% increases, reducing the overall saving by 1.5% of the excess. Once the new company's profit reaches £125,000, the saving is eliminated altogether.

Summary: Costs and Benefits of Forming a Second Company

As we have seen, the potential costs or benefits of forming a second company are dependent on the profit levels of both the original, existing company, and the new company. Costs arise where part of the small profits rate band is wasted; benefits may arise where profits can be separated out in a new company to be taxed at the small profits rate of 19% instead of the main rate of 25%; or where an existing company has less profit taxed at the marginal rate of 26.5%.

The following tables summarise the best and worst potential outcomes arising when a second company ('Newco') is formed, based on the profit level in the original, existing company.

Existing Co. Profits	Best Outcome
Up to £25,000	No impact if Newco profits do not exceed £25,000
£25,000 to £125,000	No adverse impact provided Newco profits are at least £25,000
£125,000 to £225,000	Saving of 1.5% of profits in excess of £125,000
£225,000 or more	Saving of £1,500

Existing Co. Profits	Worst Outcome
Up to £125,000	Additional cost of up to £1,875
£125,000 to £250,000	Additional cost of £1,875 less 1.5% of profits in excess of £125,000
£250,000 or more	No impact if Newco does not make a profit, or makes a profit of at least £125,000

Note, the worst outcomes described above do not include cases where Newco makes losses that cannot be relieved (e.g. where the companies are associated, but not grouped: see Section 2.9). For example, when I said there is 'nothing to lose' when the existing company is making profits in excess of £250,000, this did not include cases where unrelieved losses arise in Newco.

Third and Subsequent Companies

Similar principles apply when we look at the costs or benefits of forming third, or subsequent, companies, although the thresholds to consider are, of course, different (see Section 2.4), and the maximum impact gradually diminishes the more companies we look at. From a tax planning perspective, the position grows steadily more complex, as we need to look at the profit levels in each of the associated companies.

The maximum cost of setting up a third company is £1,250; the maximum benefit is £1,000.

The maximum cost of setting up a fourth company is £938; the maximum benefit is £750.

The maximum cost of setting up a fifth company is £750; the maximum benefit is £600.

And so on...

However, these costs and benefits do not apply cumulatively, only to each step in isolation. Moving directly from one company to multiple companies has a different impact, as follows:

The maximum cost of setting up two additional companies is £2,500; the maximum benefit is £2,000.

The maximum cost of setting up three additional companies is £2,813; the maximum benefit is £2,250.

The maximum cost of setting up four additional companies is £3,000; the maximum benefit is £2,400.

And so on...

Such a strategy might provide sufficient benefit to be worthwhile in certain, limited circumstances although, as can readily be seen from the above figures, the 'law of diminishing returns' applies.

Example U, Part 1

Karen's company, Fhuaran Ltd, makes annual profits of £400,000. She has an opportunity to set up four new branch operations, each of which will make an additional annual profit of around £10,000. Keeping all of the business in one company will result in total profits of £440,000 and a Corporation Tax bill (at 25%) of £110,000.

However, if Karen puts each of the new branches in a separate subsidiary company, she will have five companies in total, and each of them will have a lower limit of £10,000 for the purposes of the small profits rate (see Section 2.4). If her plan works exactly as she hopes, the overall Corporation Tax bill for the group will be as follows:

Fhuaran Ltd: £400,000 x 25% £100,000
Subsidiaries: £10,000 x 19% = £1,900 (each) x 4 £7,600
Total £107,600

It's a lot of effort for a maximum saving of just £2,400 and the saving is reduced if any of the new companies make profits that deviate above or below their lower limit (£10,000 in this case).

Example U, Part 2

In their first year of trading, two of the subsidiaries make profits of £12,000 each and the other two make £8,000 each. The total profits of the group remain £440,000 meaning the Corporation Tax bill would have again been £110,000 if all the business had been kept in one company. However, the actual position will be as follows:

Fhuaran Ltd: £400,000 x 25% £100,000
More profitable subsidiaries:
£10,000 x 19% x 2 £3,800
£2,000 x 26.5% x 2 £1,060
Less profitable subsidiaries:
£8,000 x 19% x 2 £3,040
Total £107,900

The saving now is just £2,100 (£110,000 – £107,900).

Such small savings will often be outweighed by the costs of running multiple companies so, as a tax planning strategy in its own right, its merits are questionable. However, where the original company has annual profits of at least £250,000 and none of the companies make losses that cannot be relieved (easily prevented by forming a group: see Section 2.9), there can never be any extra Corporation Tax cost created by forming additional companies.

Hence, while it has little value as a tax planning strategy, it is worth knowing that forming multiple companies under these

circumstances will not lead to additional Corporation Tax costs where there are good commercial reasons for doing so.

Final Summary: Costs & Benefits of Multiple Companies

Forming additional companies can lead to extra Corporation Tax costs, small Corporation Tax savings, or no change at all, depending on the circumstances.

It is important to be aware of the potential extra costs, even if the commercial benefits of having additional companies outweigh them. The risk of extra Corporation Tax costs is limited if all associated companies are also group companies.

The potential savings are generally too small to be of any practical value in their own right, but may provide an additional incentive when they fit alongside a good commercial rationale for using multiple companies.

2.7 TRANSITIONAL RULES

Where a company's accounting period straddles the date of the Corporation Tax rate changes on 1st April 2023, it will be subject to transitional rules. These rules will affect every company that does not prepare accounts to 31st March each year.

First, we must allocate the company's profits into the relevant Financial Years in the same way we looked at in Section 1.2. So, for example, a profit of £100,000 for a twelve month accounting period ending 31st December 2023 would be split as follows:

2022 Financial Year: £100,000 x 90/365 £24,658
2023 Financial Year: £100,000 x 275/365 £75,342

The amount falling into the 2022 Financial Year is not subject to the Corporation Tax rate changes and continues to be taxed at the current rate of 19%, giving rise to a Corporation Tax bill of £4,685 (£24,658 x 19%).

However, the amount falling into the 2023 Financial Year must be taxed as it if were a separate, short accounting period, that does fall within the new rules.

As we saw in Section 2.2, the upper and lower limits for a nine month (275 day) accounting period ending on 31st December 2023 will be £187,842 (£250,000 x 275/366) and £37,568 (£50,000 x 275/366) respectively. (As explained in Section 1.2, the 2023 Financial Year is a 'Leap Financial Year' of 366 days' duration.)

The amount of profit falling into the 2023 Financial Year is £112,500 less than the relevant upper limit (£187,842 – £75,342) and the Corporation Tax on this profit is calculated as follows:

£75,342 x 25%	£18,836
Less Marginal Relief	
£112,500 x 3/200	(£1,688)
Corporation Tax due	£17,148

Combining this with the tax on profits falling into the 2022 Financial Year gives a total Corporation Tax bill of £21,833 (£17,148 + £4,685). Hence, the company's overall effective Corporation Tax rate is 21.833%. We will return to this scenario at the end of this section to see how the same result can be obtained using effective marginal tax rates.

The Leap Year Mismatch

In this example, the profits of a 365 day accounting period were split between two Financial Years. However, the upper and lower limits applying in the 2023 Financial Year are allocated over a 366 day period. The practical impact of this is that, for companies with twelve month accounting periods ending on any date between 1st April 2023 and 28th February 2024, the element of profit falling into the 2023 Financial Year will:

- Attract the small profits rate if the profits of the whole year are no more than £49,863
- Attract marginal relief if the profits of the whole year are between £49,863 and £249,317
- Be taxed at the main rate of 25% if the profits of the whole year are more than £249,317

The differences created by this leap year quirk are not great. The maximum amount of extra tax arising as a result is less than £10! But if your company is making profits of £50,000 and you're getting marginal relief, instead of being taxed at the small profits rate, you'll know why.

The leap year mismatch does not affect twelve month accounting periods ending after 28th February 2024. Those ending between 29th February 2024 and 30th March 2024 do not suffer any 'mismatch', although they continue to be subject to the transitional rules; those ending on or after 31st March 2024 are taxed as outlined in Section 2.1, regardless of whether there is any mismatch between the length of the accounting period and the length of one of the Financial Years its profits fall into.

Average Tax Rates under Transitional Rules

As we saw above, the average tax rate for a company making profits of £100,000 for the year ending 31st December 2023 is 21.833%. Some more average rates for accounting periods straddling 1st April 2023 are given in the table below.

Corporation Tax Payable for Accounting Periods Straddling 1st April 2023

Year Ending:	30-Jun-2023		30-Sep-2023		31-Dec-2023	
Profits	Tax	Average Rate	Tax	Average Rate	Tax	Average Rate
£50,000	£9,503	19.005%	£9,505	19.010%	£9,508	19.015%
£60,000	£11,590	19.316%	£11,781	19.635%	£11,973	19.955%
£70,000	£13,677	19.538%	£14,057	20.082%	£14,438	20.626%
£80,000	£15,764	19.704%	£16,333	20.417%	£16,903	21.129%
£90,000	£17,850	19.834%	£18,609	20.677%	£19,368	21.520%
£100,000	£19,937	19.937%	£20,885	20.885%	£21,833	21.833%
£125,000	£25,155	20.124%	£26,575	21.260%	£27,996	22.397%
£150,000	£30,372	20.248%	£32,265	21.510%	£34,158	22.772%
£175,000	£35,590	20.337%	£37,955	21.689%	£40,321	23.041%
£200,000	£40,807	20.404%	£43,646	21.823%	£46,484	23.242%
£225,000	£46,025	20.455%	£49,336	21.927%	£52,646	23.398%
£250,000	£51,240	20.496%	£55,021	22.008%	£58,801	23.521%

Notes to the Table
- Profits are for a twelve month accounting period
- The company has no associated companies (see Section 2.5)
- The company is not subject to any of the exceptions covered in Section 2.8

Marginal Corporation Tax Rates and Effective Upper and Lower Limits

Similar principles apply to determine the effective marginal rates applying to profits arising in accounting periods straddling 1st April 2023.

For example, for a twelve month accounting period ending on 31st December 2023, we know that 90/365ths of the profit is taxed at the current Corporation Tax rate of 19%, but the other 275/365ths is taxed at the new rates applying from 1st April 2023.

If that 275/365ths is taxed at the small profits rate, then the overall rate for the year as a whole remains 19%.

If that 275/365ths is eligible for marginal relief then we know the effective marginal rate on that part of the company's profit is 26.5% (Section 2.3). This creates an effective marginal rate for the year as a whole of 19% x 90/365 + 26.5% x 275/365 = 24.651%.

If that 275/365ths is subject to the future main rate of Corporation Tax, 25%, the effective marginal rate for the year as a whole will be 19% x 90/365 + 25% x 275/365 = 23.521%.

Having derived these marginal rates, we can again use them as a shortcut to calculate the company's Corporation Tax bill. However, we need to remember the quirk caused by the leap year mismatch, which means, for a twelve month accounting period ending any time between 1st April 2023 and 28th February 2024, the effective upper limit is £249,317 and the effective lower limit is £49,863.

Example
Bhrotain Ltd makes a profit of £100,000 for the year ending 31st December 2023. Its Corporation Tax may be calculated as follows:

£49,863 x 19%	*£9,474*
£50,137 x 24.651%	*£12,359*
Total	*£21,833*

As we can see, the calculation using effective marginal rates produces the same result as we saw earlier in this section, but with considerably less effort. Once you know the marginal rates, that is: which is why I have set out the relevant rates for any twelve

month accounting period ending at the end of a calendar month in Appendix A.

Appendix A also demonstrates the fact that the first companies to be affected by the Corporation Tax increases will be those drawing up accounts for the year ending 30th April 2023. This means profits arising as early as May 2022 are already subject to tax increases in many cases.

2.8 COMPANIES PAYING CORPORATION TAX AT DIFFERENT RATES

The tax rates set out in the previous sections of this chapter apply to the vast majority of companies paying UK Corporation Tax. However, there are a few exceptions to be aware of, as detailed below.

While the companies listed here are subject to different Corporation Tax rates, they will still have to be included as associated companies, where appropriate, subject to the exceptions listed in Section 2.5.

Close Investment Holding Companies

Close investment holding companies are not eligible for the small profits rate or marginal relief and will pay Corporation Tax at the main rate of 25% on all profits arising after 31st March 2023.

A company is a 'close investment holding company' if it is a close company (Section 1.3) and does not exist wholly or mainly for a qualifying purpose. 'Wholly or mainly' is taken to mean more than half the company's activities.

Fortunately, 'qualifying purposes' include carrying on a trade or renting property to unconnected persons. Hence, the vast majority of trading companies, or companies carrying on a property letting business, will *not* be close investment holding companies and will be eligible for the small profits rate or marginal relief, where appropriate.

Non-Resident Companies

Non-UK resident companies are not eligible for the small profits rate or marginal relief and will pay tax at the main rate of 25% on any profits or gains arising after 31st March 2023 which are subject

to UK Corporation Tax. Among others, this will affect non-UK resident companies renting out, or developing, UK property.

Multinationals

Members of multinational groups may be subject to the 'Diverted Profits Tax' on part of their income. The rate of this tax is to increase from 25% to 31% from 1st January 2023.

Companies in the Oil and Gas Sector

Companies operating in the oil and gas sector pay Corporation Tax at different rates on so-called 'ring-fence' profits.

Bank Surcharge

Companies in the banking sector pay the bank surcharge on top of their normal Corporation Tax liability. The surcharge is currently 8%, but will reduce to 3% from 1st April 2023. The surcharge only applies to profits in excess of £25m (£100m from 1st April 2023).

Northern Ireland

Different rates may apply to companies trading in Northern Ireland at some point in the future. For a long time, it was thought the rate was likely to match the 12.5% rate currently used in the Irish Republic but, as that rate is to increase to 15% in the near future, and the main rate in the rest of the UK is also to increase substantially, the position now is unclear. Furthermore, the date of introduction for the special rate for Northern Ireland remains uncertain.

2.9 GROUP COMPANIES

In Section 2.4, we looked at the impact of associated companies. Companies can be associated in a number of ways, including when they form a group.

However, group companies carry the distinct advantage that any losses arising in a group company can be set off against the profits in another group company. This is known as 'group relief'.

Broadly speaking, two companies are grouped for group relief purposes when one company owns at least 75% of the shares in the other company, or when a third company owns at least 75% of the shares in both of them.

Example

Laura owns 51% of the shares in Arkle Ltd and all the shares in Eildon Ltd. Arkle Ltd also has three subsidiary companies: it owns 100% of the shares in Beacon Ltd; 75% of the shares in Clent Ltd; and 60% of the shares in Dunmoor Ltd.

While all five companies are associated, only Arkle Ltd, Beacon Ltd, and Clent Ltd are group companies. Hence a loss arising in Clent Ltd could be set off against the profits in Beacon Ltd. However, losses arising in either Dunmoor Ltd or Eildon Ltd could not be set off against profits in any of the other companies, even though they are associated.

Optimising the Value of Group Relief

Where companies are grouped, losses arising in one company can be relieved against profits in any other group company. Any amount of loss can be relieved against any other group company's profits. This flexibility is useful when we consider the different marginal tax rates applying (see Section 2.3).

Example Continued

For the year ending 31ˢᵗ March 2024, the results for the companies in the Arkle Group are as follows:

Arkle Ltd:	£75,000 profit
Beacon Ltd:	£25,000 profit
Clent Ltd:	£20,000 loss

Each company has four associated companies, meaning its lower limit is £10,000 and its upper limit is £50,000. The first £10,000 of profit in each company is taxed at 19%; the next £40,000 suffers an effective marginal rate of 26.5%; anything over £50,000 is taxed at 25%.

Hence, if Clent Ltd's loss is set against Arkle Ltd's profit, it will save Corporation Tax as follows:

£20,000 x 25%	£5,000

Alternatively, if the loss is set against Beacon Ltd's profit, it will save Corporation Tax as follows:

£15,000 x 26.5%	£3,975
£5,000 x 19%	£950
Total	£4,925

But neither is the best strategy. What Laura should do is claim to set £15,000 of Clent Ltd's loss against Beacon Ltd's profit, thus bringing its profits chargeable to Corporation Tax down to £10,000, meaning it pays Corporation Tax at the small profits rate of 19%. The remaining £5,000 of the loss can then be set against Arkle Ltd's profit. This will save Corporation Tax as follows:

Beacon Ltd
£15,000 x 26.5% *£3,975*
Arkle Ltd
£5,000 x 25% *£1,250*
Total (both companies) *£5,225*

As the example demonstrates, the best strategy is to first set losses against any group profits being taxed at the 26.5% marginal rate, then any excess against profits being taxed at the main rate of 25%. Only once these options have been exhausted should losses be set against profits subject to the small profits rate.

This is a good example of why marginal tax rates are generally more important in tax planning than average, or overall tax rates. Before the group relief claim, Beacon Ltd's average tax rate was 23.5%, whereas Arkle Ltd's was 25%. However, the best value for the first £15,000 of Clent Ltd's losses came from setting them against Beacon Ltd's profits, saving tax at the marginal rate of 26.5%.

Once Beacon Ltd's tax rate had been brought down to 19%, the best saving came from setting the remaining £5,000 against Arkle Ltd's profits, saving tax at 25%.

The best tax savings are all about looking at marginal rates, and we will see more of this type of planning in the next chapter.

2.10 COMPANIES WITH DIVIDEND INCOME

As explained in Section 1.2, dividends received by companies are, in themselves, generally exempt from Corporation Tax.

However, for accounting periods ending after 31st March 2023, dividends received from external investments (i.e. not from subsidiary companies) will often lead to an increase in the Corporation Tax payable on the rest of the company's profits.

This is because, from 1st April 2023, Corporation Tax rates will be based not on the company's taxable profits but on its 'augmented profits'.

Augmented profits are made up of the company's taxable profits **plus** dividends received: except for dividends received from a subsidiary company. Broadly speaking, a subsidiary company is one in which the recipient company owns more than 50% of the share capital.

If the company's augmented profits exceed the lower limit, the company will not be entitled to the small profits rate of 19%, but will be entitled to marginal relief, provided the augmented profits are less than the upper limit. However, if the augmented profits exceed the upper limit, the company will pay Corporation Tax rate at the main rate of 25%, but only on its taxable profits.

Many companies will be affected by this peculiar quirk in the new Corporation Tax regime, although it is worth pointing out that it will not affect:

- Companies with **augmented** profits not exceeding £50,000 (or the lower limit applying in their case, if this is less)
- Companies with **taxable** profits of at least £250,000 (or the upper limit applying in their case, if this is less)
- Companies with no dividend income
- Companies whose only dividend income comes from subsidiaries

Where the augmented profits quirk does apply, however, life gets complicated. First, the company's marginal relief is calculated based on its augmented profits and then the relief is reduced by the proportion of taxable profits to augmented profits.

Example
In the year ending 31st March 2024, Chochuill Ltd makes trading profits of £90,000 and also receives dividends of £10,000 from various investments. This means its augmented profit is £100,000 or £150,000 less than the upper limit of £250,000. Its marginal relief is calculated as follows:

£150,000 x 3/200 x £90,000/£100,000 = £2,025

Its Corporation Tax bill is therefore:

Taxable profits £90,000 x 25% = £22,500
Less marginal relief (£2,025)
Corporation Tax £20,475

If Chochuill Ltd had not received the dividends, its Corporation Tax bill would be:

£50,000 x 19% £9,500
£40,000 x 26.5% £10,600
Total £20,100

Hence while the company's dividend income is not taxed directly, it has led to a £375 increase in its Corporation Tax bill.

Chapter 3

Marginal Rate Tax Planning

3.1 INTRODUCTION TO MARGINAL RATE PLANNING

In Section 2.3, we looked at the concept of marginal tax rates and saw the rates applying to company profits for accounting periods beginning after 31st March 2023. Section 2.7 also introduced the marginal tax rates applying to accounting periods straddling 1st April 2023, which are included in Appendix A.

The important thing to remember about your company's marginal tax rate is that this determines the amount of tax saved by:

- Incurring deductible expenditure
- Reducing taxable income
- Claiming tax reliefs and allowances

Opportunities for marginal rate tax planning arise whenever there is a change in your company's marginal tax rate. Your company's marginal tax rate may change from year to year due to a number of possible factors:

- Changes in Corporation Tax rates: in particular, the increases planned for 1st April 2023
- Changes in the number of associated companies your company has (see Section 2.4)
- Increases or reductions in your company's taxable profits due to:
 - Commercial factors,
 - Tax deductible investment in company assets (see Chapter 4), or
 - Group relief (see Section 2.9)

At the time of writing (October 2022), many companies with accounting dates between April and September have already seen an increase in their marginal tax rate; many with accounting dates between October and March will see an increase soon; and many with any accounting date other than 31st March will see a second

increase next year. All companies' marginal tax rates may also change from year to year in the future. All these changes provide the opportunity to make additional tax savings.

Example

Foinaven Ltd is a property investment company and draws up accounts to 31st March each year. It anticipates making profits of between £200,000 and £225,000 each year, before any exceptional expenditure. The company plans to upgrade some of its properties and is satisfied the expenditure will be classed as tax deductible repairs rather than improvements. (The scope of what may be classed as property repairs rather than improvements is often more generous than many people realise: for a detailed examination of the topic see the Taxcafe.co.uk guide 'How to Save Property Tax'.)

This exceptional repairs expenditure will cost £100,000 but, while the company would like to carry out the work in the near future, it is by no means urgent.

If Foinaven Ltd carries out the repairs during the year ending 31st March 2023 it will get Corporation Tax relief at 19%, saving £19,000. However, if the repairs are deferred until after 31st March 2023, the company will then have a marginal Corporation Tax rate of 26.5% and the same expenditure will produce £26,500 worth of tax relief.

In other words, the company can save £7,500 simply by deferring its expenditure until after 31st March 2023.

Many companies will be anticipating an increase in their marginal Corporation Tax rate after 31st March 2023, meaning that deferring expenditure, where it is possible to do so, will yield additional tax savings. We will look at more examples of how this might be done later.

In later years, it is possible that a company may see a decrease in its marginal tax rate: when profits fall below the lower limit of £50,000 (the marginal rate reduces from 26.5% to 19%); when profits rise above the upper limit of £250,000 (the marginal rate reduces from 26.5% to 25%); or when there is a change in the number of associated companies (so that the limits themselves change: see Section 2.4).

The surprising part of this is that a company's marginal tax rate will sometimes decrease when profits are increasing.

Example

Gavel Ltd is anticipating making profits of £200,000 for the year ending 31ˢᵗ March 2024. This will give the company an average, overall tax rate of 24.625% (see Section 2.1) and a marginal rate of 26.5%.

For the year ending 31ˢᵗ March 2025, the company expects its profits to increase to £400,000. This will give the company both an average, and marginal, Corporation Tax rate of 25%. In other words its average rate will increase but its marginal rate will reduce. These projected profit figures are before exceptional repairs of £120,000 which the company plans to carry out in the first half of 2024. If the expenditure is incurred by 31ˢᵗ March 2024, it will save tax at 26.5%, or £31,800; if it is incurred later, it will save tax at 25%, or £30,000.

In this case, the company will save an additional £1,800 by accelerating its expenditure into the earlier accounting period to get tax relief at a higher marginal rate.

This example shows again that **marginal tax rates are critical to tax planning, rather than average, overall rates.**

Deductible Expenditure

Marginal rate tax planning is not about incurring additional expenditure: it is seldom wise to spend extra money just to save tax. It is about the timing of expenditure. Because changing that timing can change the value of the tax relief you get for the expenditure.

Naturally, there are many types of expenditure a company is unable to control the timing of, such as business rates or employee's wages. Furthermore, under the 'accruals basis' of accounting, which companies must always follow, expenditure is recognised as it is incurred rather than when it is paid. Hence, simply paying a bill early or late will not alter the timing of your company's tax relief, or the marginal rate that applies.

Furthermore, even when you can alter the timing of when expenditure is incurred, the commercial implications of deferring or accelerating that expenditure need to be weighed up: the decision should not be driven by tax rates alone.

Nonetheless, expenditure that can sometimes be accelerated or deferred includes:

- Repairs and maintenance (where there is some discretion over timing)
- Advertising and promotion
- Travel and subsistence (by altering the timing of business journeys)
- Employee bonuses (where these are discretionary or gratuitous, rather than contractual; but see also Section 3.6)
- Staff entertaining
- Staff recruitment (agents' commission will generally be a deductible expense)
- Pension contributions (see Section 3.3)
- Equipment, software, commercial vehicles, and other asset purchases (we will cover these in Chapter 4, as there are other tax implications to be considered)
- Legal and professional costs, such as business advice, or consultancy (provided these are not capital expenditure or regular, annual costs that would be recognised in the accounts in any case)

Purchases of trading stock can sometimes be accelerated or deferred, but this, in itself, will not alter the timing of tax relief for the expenditure (but see Section 3.2 regarding accounting adjustments for trading stock).

Business entertaining can be accelerated or deferred. However, as it is not an allowable expense for tax purposes, the company's Corporation Tax rate has no impact on the overall, net, after tax cost. Sometimes, however, there is a 'substitution effect' to be considered, and we will look at that in Section 3.8.

Taxable Income

It is not generally possible to reduce *taxable* income without reducing *actual* income: something that, again, is seldom wise. Hence, marginal rate planning is not generally about reducing overall long-term income, only about altering the timing of when that income is received, or taxed. We will see some ways in which this might be done in Section 3.2.

Tax Relief

While your ability to change the timing of when expenditure is incurred by your company may be limited, there is sometimes scope to alter the timing of tax relief for some of that expenditure, and we will see some examples of this in Sections 3.2 and 3.4.

Marginal rate planning is (generally) **all about timing!**

3.2 SAVING TAX BY ACCELERATING PROFITS

Every company with annual profits in excess of £50,000 is going to see an increase in its marginal tax rate. For those with a 31st March accounting date, this will happen in a single step, as profits in excess of £250,000 move from being taxed at 19% to being taxed at 25%; while profits between £50,000 and £250,000 move from being taxed at 19% to being taxed at 26.5%.

Other companies will see the increase happen in two stages, with all profits being taxed at 19% in the last accounting period ending before 1st April 2023; then profits in the next period taxed at the rates shown in Appendix A (as explained in Section 2.7); and profits in the period after that taxed at 25% for profits over £250,000 and 26.5% for profits between £50,000 and £250,000.

All companies with annual profits in excess of £50,000 will save tax by accelerating profits into an earlier accounting period before the tax increase, or, for those without a 31st March year end, into one of the periods before the increase has been fully implemented. Here are some examples of the savings available:

Annual Profits Between £50,000 and £250,000
Accelerating £10,000 of profit from:
Year ending 30 June 2023 to year ending 30 June 2022 saves £187
Year ending 30 Sep 2023 to year ending 30 Sep 2022 saves £376
Year ending 31 Dec 2023 to year ending 31 Dec 2022 saves £565
Year ending 31 Mar 2024 to year ending 31 Mar 2023 saves £750
Year ending 30 June 2024 to year ending 30 June 2023 saves £563
Year ending 30 Sep 2024 to year ending 30 Sep 2023 saves £374
Year ending 31 Dec 2024 to year ending 31 Dec 2023 saves £185

Companies with Annual Profits Over £250,000

Accelerating £10,000 of profit from:
Year ending 30 June 2023 to year ending 30 June 2022 saves £150
Year ending 30 Sep 2023 to year ending 30 Sep 2022 saves £301
Year ending 31 Dec 2023 to year ending 31 Dec 2022 saves £452
Year ending 31 Mar 2024 to year ending 31 Mar 2023 saves £600
Year ending 30 June 2024 to year ending 30 June 2023 saves £450
Year ending 30 Sep 2024 to year ending 30 Sep 2023 saves £299
Year ending 31 Dec 2024 to year ending 31 Dec 2023 saves £148

The greatest savings are available to a company with a March year end, making annual profits between £50,000 and £250,000.

As we can see from these examples, the savings at stake generally aren't huge, so it certainly isn't worth doing anything that doesn't make commercial sense. But small timing changes on a few items could make enough difference to be worthwhile.

But how do you accelerate taxable profits? There are four possible methods available:

- Defer expenses
- Accelerate income
- Accelerate capital gains
- Review your accounting adjustments carefully (this has the advantage of having no commercial implications for your business, although the scope here is naturally limited)

The last method, though limited in scope, still remains a possibility for company accounting periods which have ended, but for which the accounts have not yet been finalised.

Deferring Expenses

We've already looked at deferring repairs in Section 3.1. Many of the other items worth considering are also listed in Section 3.1. Let's have a quick look at some of the potential savings.

Example
Ingleborough Ltd anticipates making a profit of £200,000 in the year ending 31ˢᵗ March 2024. To help the company reach this target, Simon, the managing director, is planning to launch a sales and promotion campaign involving £20,000 advertising expenditure and a sales trip,

which will cost a total of £10,000. He also plans to redecorate the company's offices, at a cost of £8,000.

If all this expenditure, totalling £38,000 takes place before 31st March 2023, it will provide Corporation Tax relief at 19%. However, if Simon defers the expenditure until April, the expenditure will provide Corporation Tax relief at the company's marginal rate of 26.5%, thus producing an additional saving of £2,850 (£38,000 x 7.5%).

The key question for Simon is whether there are any commercial implications of delaying this expenditure that may cost the company more than it saves in Corporation Tax. Of course, he needs to remember a saving of £2,850 in tax is worth £3,878 in pre-tax profits but, even so, he should never forget that it's profits after tax that matter, not how much tax you pay!

Note that deferring capital expenditure has an entirely different set of consequences, and we will look at these in Chapter 4.

Accelerating Income

The happy coincidence the increase in Corporation Tax rates brings is that it will both save tax **and** make commercial sense to accelerate income so that it falls into an earlier accounting period in which your company has a lower marginal tax rate.

So, get out there and sell! Well, that's obvious, but what else should you consider as you get close to one of those critical accounting dates (broadly any year end accounting date between now and February 2024). Here are some possible steps:

- Complete orders and projects and bring billing up to date. Accounting rules often require part-completed work to be brought into account, but there is still a large element of profit dependent on completion and billing in many cases. For example, two half completed projects are, in accounting terms, likely to yield less profit than a single completed project of the same size.

- Connected businesses (e.g. wife has her own company, husband also has his own business): make extra sales to connected businesses in advance of the company's accounting date.

Accelerating Capital Gains

This is well worth looking at, as there will often be much larger amounts at stake, although it is only worth considering where an asset disposal was already under consideration. We will look at this further in Section 3.7.

Accounting Adjustments

Carefully considered accounting adjustments can slightly alter the timing of company profits. While accounts must be prepared on a reasonable, 'true and fair' basis, there is often some leeway in the exact amount of each accounting adjustment. With most companies' marginal Corporation Tax rates set to increase, it may make sense to maximise profits in the last accounting period before the Corporation Tax increase begins to take effect.

Of course, it is only worth increasing the profits taxed at 19% if the relevant accounting adjustments will subsequently reverse and thus reduce profits in later accounting periods taxed at higher marginal rates. In other words, we need to be looking at timing differences that will reverse in a later accounting period.

Subject to these points, some of the items you could consider to help accelerate profits into an earlier accounting period with a lower marginal Corporation Tax rate are considered below. Within the bounds of what is reasonable, and within the scope of generally accepted accounting practice, in your company's accounts for its last accounting period before the Corporation Tax increase begins to take effect, you could minimise:

- Bad debt provisions
- Provisions for obsolete, damaged, or slow-moving trading stock
- Accruals for:
 - Utilities
 - Accountancy fees and other professional costs
 - Employees' wages, bonuses, and holiday pay
 - Unclaimed employees' expenses (e.g. business mileage claims)
 - Repairs and maintenance costs
 - Legal claims against the business
 - Banks charges and interest on loans, including hire purchase agreements

On the other hand, and again within the bounds of what is reasonable, and within the scope of generally accepted accounting practice, you could maximise:

- Your closing stock valuation: have you included all your production overheads, such as factory or workshop electricity costs and business rates; have you included office stationery, like part-used printer cartridges and ink; have you included fuel still in the tank of a company vehicle at the accounting date?
- Closing work in progress values, particularly in:
 o Property development companies
 o Other companies in the construction sector
 o Manufacturing companies
 o Service businesses operating within a company, such as accountants, lawyers, surveyors, architects, or graphic designers
- Prepayments (see further below)

Maximising Prepayments

Prepayments are the opposite of accruals: costs the company has already paid but which wholly or partly relate to a later accounting period. By classing part of the amount already paid as a prepayment, you will defer part of the expense to the next accounting period, thus increasing this period's taxable profits and reducing the next period's.

This is correct accounting procedure at any time but, when your company's marginal tax rate is likely to be higher in the next accounting period, you might just want to try that little bit harder to identify as many prepayments as possible.

Typical items to consider include:

- Insurance premiums
- Subscriptions
- Vehicle excise duty (road tax)
- Standing charges within utility bills
- Rent paid (especially if quarterly)
- Finance charges on long-term loans

3.3 PENSION CONTRIBUTIONS

One of the main types of expenditure a company owner can control the timing of is pension contributions. Here we are talking about voluntary pension contributions for the owner/director themselves, rather than any contractual entitlement the company's employees may have, or compulsory contributions under auto-enrolment.

Pension contributions made by a company on behalf of an owner/director will generally attract Corporation Tax relief. Technically, the contributions, plus any salary and other benefits provided to the director, must not exceed a reasonable level of remuneration for the director's contribution to the company's business. However, in the case of the owner/director of a private company, there will seldom be any difficulty over this point, provided the company remains in profit after paying the pension contribution.

Unlike a salary, pension contributions carry the advantage of being free from National Insurance. Income Tax is also effectively deferred until the owner/director takes their pension. For younger directors, however, there is the disadvantage that the pension is effectively locked away until they reach the age of 55 (rising to 57 from 2028).

By deferring pension contributions until the company has a higher marginal tax rate, it may be possible to make extra Corporation Tax savings. However, this strategy carries some risks and is also subject to a few practical limitations.

Firstly, it may be necessary to defer the contributions for quite some time in some cases. For example, if your company has a 31st December year end and is making annual profits in excess of £50,000, you will have to wait until January 2024 to get the best rate of Corporation Tax relief on your pension contributions. Some company owners may not be willing to postpone contributions for that long, as cash kept inside a company is arguably more vulnerable to commercial risk than cash invested in a pension.

Furthermore, it is important to remember there are annual limits on qualifying pension contributions made by, or on behalf of, each individual. At present, the annual allowance is £40,000,

which means your company can generally make contributions of up to £40,000 per year on your behalf.

However, where you were a member of a qualifying pension scheme in any of the three previous tax years, and had any unused annual allowance in those years, the rules currently also allow you to utilise that unused allowance. This means, in some cases, it may be possible to make a contribution of up to £160,000.

Example

Sandra is the owner/director of Haystacks Ltd. The company has a 31st December accounting date and normally makes a pension contribution of £40,000 on Sandra's behalf each year. The company's annual profits are steady at around £225,000 before Sandra's pension contribution.

If the company carries on making its annual contribution of £40,000, it will obtain tax relief as follows:

2022: £40,000 x 19% £7,600
2023: £40,000 x 24.651% £9,860 (* see Appendix A)*
2024: £40,000 x 26.5% £10,600

The total Corporation Tax saved amounts to £28,060.

However, if the company defers its contributions in 2022 and 2023, and makes a single contribution of £120,000 in 2024 instead, the Corporation Tax saving will amount to £31,800 (£120,000 x 26.5%).

Hence, deferring her pension contributions saves Sandra's company an additional £3,740.

Further limits on pension contributions can apply to some individuals with taxable income in excess of £240,000 (before pension contributions) or existing pension entitlements with a deemed total gross capital value over £1,073,100. The annual allowance can also be used up by contributions into another pension scheme on your behalf, or by increased benefits accruing under a defined benefit scheme (e.g. if you are also employed in another company). The allowance may also be reduced if you have made prior withdrawals from a pension scheme. See the Taxcafe.co.uk guide *'Pension Magic'* for further information.

Despite these limitations, many company owners may be able to enjoy similar additional Corporation Tax savings to Sandra, in our example, by postponing their pension contributions. However, it is important to be aware it is possible there could be additional, or more severe, restrictions on pension contributions in the future. This could make it difficult, or less beneficial, to follow the strategy outlined above; so it is something to keep an eye on.

3.4 OTHER WAYS TO ACCELERATE TAXABLE PROFITS

The company's reported profit before tax for the accounting period, as per its accounts, forms the basis for its taxable profit. However, there are a number of adjustments between the accounting profit and the taxable profit.

As we know, most companies will benefit by accelerating more profit into the last accounting period ending before the Corporation Tax increases take place on 1st April 2023. In some instances, the company can accelerate its taxable profit without necessarily accelerating its profit per the accounts.

General Provisions

To be allowed for tax purposes, a provision must be calculated on a specific basis, using the most reasonable estimates available at the time the accounts are being prepared. General provisions are not allowed for tax purposes. Hence, by making general provisions instead of specific ones, a company can accelerate its taxable profits.

Note, however, that companies must still observe generally accepted accounting practice when making provisions in their accounts and this limits the scope for general provisions.

Late Bonus Payments

Staff bonuses in respect of an accounting period must actually be paid within nine months of the accounting date to be allowed for tax purposes. Hence, by paying bonuses more than nine months after the accounting date, a company can effectively accelerate its taxable profits (the bonuses will be allowed once they are paid). See Section 3.6 for some other issues to consider regarding the timing of bonus payments.

Depreciation and Asset Write-Offs

Depreciation and similar charges put through the accounts are not allowed for tax purposes. Hence, if a company wishes to show a more prudent position without reducing profits chargeable to Corporation Tax at a lower marginal rate, it can increase depreciation and similar charges in its accounts.

3.5 CASHFLOW IMPLICATIONS

Accelerating taxable profits has cashflow implications that should be considered. By accelerating your company's taxable profits, you are also accelerating your Corporation Tax liability. Companies with a 31st March accounting date generally need to accelerate some of their tax liability by a year to get the benefit of the techniques described in the previous sections; those with other accounting dates may need to accelerate their liability by two years to get the full benefit.

In some cases, the accelerated tax liability is partly compensated for by a delay in expenditure, but this is seldom for as long a period.

So, cashflow is certainly a factor to be considered. However, it is worth remembering that paying tax early at 19% will often save tax later at 25% or 26.5%. Let's say paying an extra £1,900 on 1st October 2023 (i.e. Corporation Tax for an accounting period ending on 31st December 2022) will eventually reduce the payment due on 1st October 2025 by £2,650: you can look at this as investment of £1,900 that will provide a return of £750 after just two years. That's a return on your investment of almost 40%, or an annual return of just under 20%. Not bad!

If paying an extra £1,900 saves you £2,500 two years later, that's a return on your investment of almost 32%, or an annual return of just under 16%.

And returns of almost 32% or 40% can often be enjoyed in just one year when your company has a 31st March accounting date.

So, yes, a lot of marginal rate planning comes with an upfront cost, and we need to consider cashflow, but the potential investment returns are excellent.

3.6 EMPLOYEE BONUSES

In Section 3.1, we looked at various ways to save Corporation Tax by deferring expenses and one item under consideration was employee bonuses.

The reduction in National Insurance rates back to their previous, 2021/22 levels from 6th November 2022 (for regular, non-director employees) and scrapping of the planned Health and Social Care Levy which had been due for introduction on 6th April 2023 means the cost of paying employee bonuses has reduced, with both the company and the employee saving 1.25%.

While the cost of paying a bonus reduces from 6th November 2022, the Corporation Tax relief available for it will increase next year. Hence, in many cases, it will remain beneficial to defer bonuses a little longer.

Example
Stuchd an Lochain Ltd has a 31st March accounting date and makes annual profits of around £200,000. The company's owner, Heather wishes to pay a discretionary bonus of £10,000 to Arthur, one of her employees.

With employer's National Insurance back at 13.8% from 6th November 2022, (for non-director employees), the total cost of the bonus to the company will be £11,380. If the bonus is paid by 31st March 2023, it will provide Corporation Tax relief at 19%, leaving a net, after tax cost of £9,218.

Alternatively, if Heather waits until April 2023 to pay the bonus, it will provide Corporation Tax relief at the company's marginal tax rate of 26.5%. The after tax cost of the bonus would then be £8,364.

The company could save £854 by delaying the bonus payment, so this seems to be worthwhile.

The position may be different from Arthur's point of view, however. If he is a higher rate taxpayer, he will receive a net sum of £5,800 whether the bonus is paid between 6th November 2022 and 31st March 2023, or paid later.

If he is a basic rate taxpayer, however, the timing of the bonus will have a significant impact on the timing of his tax deductions.

Example Continued

Arthur receives a salary of £3,350 per month (£40,200) per year. An additional £10,000 bonus will bring his total taxable income up to £50,200 in the relevant year and he will still be a basic rate taxpayer.

If he receives the bonus in March 2023, he will therefore suffer Income Tax at 20% plus National Insurance at 12% on the first £839 and 2% on the remainder. He will therefore receive a net sum of £7,716.

If he receives the bonus on 30th April 2023, however, he will initially suffer an Income Tax deduction under PAYE of £3,832. This is made up of £839 at 20% plus £9,161 at 40% and is a product of the way the PAYE system works. He will suffer the same amount of National Insurance as he would have done in March, so the net bonus actually received in April is just £5,884.

The additional £1,832 in Income Tax suffered by Arthur will reverse over the course of the 2023/24 tax year, eventually leaving him in the same position as if he had received his bonus in March. However, many employees faced with such a dramatic reduction in net pay struggle to understand this and many tend to blame their employer.

When Arthur gets that April pay packet, all he may think is that, not only has he had to wait longer for his bonus, he has suffered £1,832 more tax. Heather may have some explaining to do or else the detrimental impact on Arthur's morale could eventually end up costing her more in commercial terms than that £854 Corporation Tax saving.

The position will be different for companies with different accounting dates though. For example, if Stuchd an Lochain Ltd had a 31st December accounting date, paying Arthur's bonus in March 2023 would allow him to receive the same net sum of £7,716 while providing the company with Corporation Tax relief at 24.651% (see Appendix A) and giving it an after tax cost of £8,575 for the bonus.

The saving compared with a bonus paid in the previous accounting period would then be a little less, £643, but Arthur would be much happier.

Accounting Treatment

Delaying bonus payments into a later accounting period in order to get Corporation Tax relief at a higher rate will only be effective if the cost of the bonus does not need to be recognised in the earlier accounting period.

Hence, this strategy is only effective for discretionary or gratuitous bonus payments that are not linked to an employee's performance in the earlier accounting period.

Alternatively, as explained in Section 3.4, if there is a link to past performance, it will be necessary to delay paying the bonus until more than nine months after the end of the earlier accounting period.

3.7 ACCELERATING CAPITAL GAINS

One major way to save tax will be to make sure company asset disposals you are planning to make in the near future, which will give rise to significant capital gains, take place before the Corporation Tax rate increases, wherever possible.

Naturally, this is only worth considering where a disposal is already being planned and the early disposal of the company asset has no significant adverse commercial implications.

Generally, the main types will be property disposals, including:

- Investment property held by a property letting company
- Investment property held by other companies
- Business premises for a company that is not carrying on a trade (e.g. a property letting company's own business premises)
- Qualifying furnished holiday lets that are not being replaced
- Trading premises that are not being replaced

Gains on trading premises or qualifying furnished holiday lets can generally be 'rolled over' into replacement property acquired within the period beginning one year before, and ending three years after, the disposal. Hence, there will be no Corporation Tax arising and no tax saving derived by accelerating the disposal

(although we will return to this subject later in this section). See the Taxcafe.co.uk guide *'How to Save Property Tax'* for further details on rollover relief.

Example

Jenkin Ltd is a property investment company with a portfolio of residential rental properties. It draws up accounts to 31st March each year and generally makes an annual profit of around £100,000. Jenkin Ltd is planning to sell one of its investment properties and anticipates this will yield a taxable capital gain of £500,000. If the sale takes place by 31st March 2023, the Corporation Tax arising on the capital gain will be £95,000 (£500,000 x 19%).

However, if the sale takes place after 31st March 2023, the Corporation Tax arising on the gain will effectively be:

£150,000 x 26.5%	*£39,750*
£350,000 x 25%	*£87,500*
Total	*£127,250*

In other words, making sure the sale takes place by 31st March 2023 will save the company £32,250 (£127,250 – £95,000).

What if the Sale Cannot be Completed in Time?

An important point to note is that, for capital gains purposes, a sale is deemed to take place on the date of unconditional contract. For property in England and Wales, this is generally on exchange of contracts; in Scotland it is on completion of missives.

Hence, to achieve the desired Corporation Tax saving, it is not necessary to complete the sales contract by the relevant accounting date, only to have entered an unconditional contract for the sale. Naturally, the contract must subsequently be completed and any variation to its terms may cast doubt over whether it was indeed a binding, unconditional contract at the relevant accounting date.

If it looks like it may not even be possible to enter a contract by the relevant accounting date, it could be worth dropping the price a little.

Example Revisited

It is late March 2023, and Jenkin Ltd has been unable to sell the property at its full market value of £800,000. As we already know, a sale after 31st March 2023 will give rise to a Corporation Tax bill of £127,250, leaving the company with after tax proceeds of £672,750.

Joanne, the company's owner, decides to drop the property's sale price to £775,000 in order to achieve a quick sale. She is successful and contracts are exchanged on 31st March 2023, meaning the sale falls into the year ending 31st March 2023 for tax purposes and the reduced gain of £475,000 is taxed at 19%, giving rise to a Corporation Tax bill of £90,250.

The company's after tax sale proceeds are now £684,750 (£775,000 − £90,250), or £12,000 more than if the sale had taken place at full market value, but after 31st March 2023.

For any company with a 31st March accounting date in a similar position, if it becomes necessary to drop the sale price to achieve a sale by 31st March 2023 (remembering only exchange of contracts by that date will generally be necessary), the maximum reduction in price that will still leave the company better off after tax is:

£74.07 for every £1,000 of gain that would otherwise be taxed at 25%, and
£92.59 for every £1,000 of gain that would otherwise be taxed at 26.5%

For Jenkin Ltd this would have equated to 150 x £92.59 plus 350 x £74.07, which equals £39,813. Reducing the price by £39,813 would leave a gain of £460,187 taxed at 19%, giving the company a Corporation Tax bill of £87,436 and after tax sale proceeds of £672,751 (£760,187 − £87,436). Allowing for rounding, this leaves the company in more or less the same position as a sale at full market value after 31st March 2023.

Hence, reducing the price by any less than the amount produced by this formula will leave the company better off overall if the sale can be achieved by the accounting date.

Sales before other accounting dates falling between now and February 2024 will generally also yield savings, although the precise amounts involved will differ.

Interim Sales

Another strategy some companies might consider where it is not possible to enter a sales contract with a third party by the relevant accounting date, is an interim sale to a connected party, like the company's owner, for example. The connected party would then sell the property to a third party for full market value at a later date.

This strategy is not without its problems, however. Whatever price the property is sold to the connected party for, the company will still need to pay Corporation Tax calculated on the gain arising based on a sale for the property's full market value. That is not such a problem, because triggering a Corporation Tax charge at 19% (instead of a higher rate) is actually our objective.

However, a sale at less than market value will also give rise to a 'dividend in specie' equal to the shortfall and the connected party will generally have to pay Income Tax on this amount, at normal dividend rates.

Hence, the best option will usually be to sell the property to the connected party for full market value. We then have the problem of Stamp Duty Land Tax on the sale price and, in the case of residential property this will usually need to include the 3% surcharge applying to additional properties.

All in all, it's not a strategy I would generally recommend, but it might yield a small overall saving in a few cases.

Example

Kirk Ltd has a residential property with a market value of £150,000, which it bought many years ago and which will yield a taxable capital gain of £100,000 on sale. The company draws up accounts to 31st March each year and generally makes annual profits of around £80,000. Hence, if the property is sold by 31st March 2023, the Corporation Tax arising on the capital gain will be £19,000, if it is sold later, the Corporation Tax will be £26,500.

Unable to find a third party buyer in time, Kirk Ltd sells the property to Sian, the company's owner/director in March 2023 for £150,000. Sian pays Stamp Duty Land Tax of £4,500 on the purchase. When Sian subsequently sells the property for £150,000, she will have no Capital Gains Tax to pay (she will have a £4,500 capital loss).

Ultimately, the company saves £7,500 in Corporation Tax at a cost to Sian of £4,500. There is a net saving of £3,000 but it is questionable if this is worthwhile as there will be other costs to factor in, such as legal fees, etc.

The potential overall saving might be greater where property is increasing in value and a sale is not contemplated immediately, but in the near future. However, this potential for further savings does very much depend on circumstances.

Example Revisited

Let us now suppose that Kirk Ltd is not planning to sell the property for a couple of years and that its value by the time of sale will be £166,800. This would give Kirk Ltd a taxable capital gain of £116,800 and a Corporation Tax bill, at 26.5%, of £30,952.

If, however, the company sells the property to Sian for £150,000 in March 2023, it will have a Corporation Tax bill of just £19,000. Sian will have a base cost for the property of £154,500 (£150,000 plus Stamp Duty Land Tax of £4,500) and when she sells it for £166,800 she will have a capital gain of £12,300. This will be covered by her annual exemption, leaving her no Capital Gains Tax to pay.

As we can see, the Corporation Tax saving has now increased to £11,952 (£30,952 – £19,000), or a net saving of £7,452 after taking account of the Stamp Duty Land Tax paid by Sian.

However, there remain a number of potential problems behind this strategy:

- The saving will be reduced by the transaction costs (legal fees, etc) on the interim sale.
- The owner/director will need to fund the interim purchase of the property. If the sale price for the interim sale were left outstanding as a loan, this would lead to further tax costs.
- Rental income generated by the property between the interim sale and the final sale, and thus received by the owner/director, will be subject to Income Tax rather than Corporation Tax. If the owner/director is a higher rate taxpayer that means tax at 40% instead of 26.5% (at most) in the company.

- If the owner/director has to borrow to fund the purchase of a residential rental property, interest relief will only be available at 20%.
- If the property goes up in value any more than expected, and the owner/director is a higher rate taxpayer, the additional gain will be taxed at 28% instead of 26.5% (at most) in the company.
- If the owner/director's annual Capital Gains Tax exemption is not fully available in the year of sale, more of the gain will be subject to Capital Gains Tax.
- Capital Gains Tax rates may increase before the ultimate sale.

Rollover Relief Revisited

As discussed above, it will not generally be worth trying to accelerate a sale of a property such as trading premises or a furnished holiday let where the gain arising will be rolled over into replacement property. However, it is worth mentioning a couple of exceptions.

Firstly, downsizing: where the replacement property is worth less than the one being disposed of.

Example
Lochnagar Ltd is about to sell its trading premises for £1.2m and this will yield a taxable capital gain of £400,000. The company will reinvest £900,000 of its sale proceeds in new trading premises.

Because the company is not reinvesting £300,000 of its sale proceeds in new premises, this much of its capital gain cannot be rolled over. In other words, only £100,000 of its gain can be rolled over and £300,000 will be subject to Corporation Tax.

Hence, Lochnagar Ltd will still enjoy a Corporation Tax saving by ensuring the disposal of its old trading premises takes place in an earlier accounting period when it has a lower marginal Corporation Tax rate (it could save up to £21,750, depending on its profit level and accounting date).

Secondly, short-term replacements: where the replacement property will itself be disposed of in the near future.

Let's suppose a small company is going to make a taxable capital gain of £100,000 but expects to roll this over into the purchase of a new property.

When that new property is sold, the £100,000 of rolled over gain becomes taxable. It could be rolled over again if another replacement property is being acquired but, if this is not the case, it will be taxed at the Corporation Tax rates prevailing at that time.

Hence, if a gain of £100,000 is rolled over when the company's marginal tax rate is 19%, but becomes taxable in a few years' time when the company's marginal tax rate is 26.5%, the roll over claim will have cost the company an extra 7.5%, or £7,500.

More importantly, that extra tax represents almost 40% of the tax saved by the rollover claim.

Even with a current rate of 19% and a future marginal rate of 25%, the extra tax arising on the sale of the replacement property still represents nearly 32% of the tax saved by the rollover claim.

So, if the sale of the replacement property is likely to take place any time in the foreseeable future, with no further replacement being acquired at that time, the value of making a rollover relief claim while the company's marginal Corporation Tax rate is 19% could be highly doubtful.

Calculating Taxable Capital Gains in Companies

For property or other assets purchased by companies after November 2017, the taxable capital gain arising on their disposal is fairly easy to calculate, as it is simply sale proceeds less purchase cost.

For assets acquired earlier, companies are eligible to claim indexation relief based on the increase in the Retail Prices Index between the date of acquisition and December 2017. For example, if a property was purchased in June 2000 for £100,000, the company could claim indexation relief of £62,500 on its disposal. This is because the Retail Prices Index increased by 62.5% between June 2000 and December 2017.

Where assets were transferred to the company by a connected party, the market value at the date of transfer is generally substituted for purchase cost in any subsequent calculation of the company's taxable capital gain on a disposal of the asset.

For further details see the Taxcafe.co.uk guide *'Using a Property Company to Save Tax'*.

3.8 THE SUBSTITUTION EFFECT

Changes in marginal Corporation Tax rates may alter what is the best approach to take in some cases when we are considering two alternatives, one of which attracts Corporation Tax relief and the other does not.

The question of whether a company owner should take salary or dividends is one prime example, and we will look at that in Chapter 6.

Similarly, the marginal Corporation Tax rate affects whether additional pension contributions for an owner/director might be more tax efficient than dividends, although this is very much a personal decision, with many factors to consider. See the Taxcafe.co.uk guide *'Pension Magic'* for a detailed analysis.

Another major area to consider is repairs and maintenance versus replacement or improvement expenditure, particularly when it comes to business premises, or other property held by the company.

Example
The old trading premises Moruisg Ltd operates from are very run down and in need of constant repair. The annual repair bill now amounts to £20,000. Alternatively, the company could buy new premises at a cost of £150,000 and would then have negligible repair costs for the next ten years.

Assuming no tax relief is available on the purchase of new premises, its cost after tax relief is still £150,000 (but see further below). The cost of ten years' worth of repairs on the old property is £200,000, but this will attract Corporation Tax relief.

Hence, comparing the after tax cost of both alternatives (and ignoring any other factors), we see that:

With a marginal Corporation Tax rate of 19%, the net cost of the repairs after tax is £162,000 and the company would be better off buying new premises.

With a marginal Corporation Tax rate of 25%, the net cost of the repairs after tax is £150,000 so it makes no difference whether the company stays put or invests in new premises.

With a marginal Corporation Tax rate of 26.5%, the net cost of the repairs after tax is £147,000 and the company would be better off staying put in its old premises.

In practice, there will be many other factors to consider in this decision, both commercial ones and tax ones. As far as tax is concerned, the company would have to factor in:

- Any capital allowances available on the new property, including the structures and buildings allowance
- Whether there was a capital gain (or loss) on disposal of the old property (but see Section 3.7 regarding rollover relief)
- Any capital gain that may arise on the new property
- Any increase in Business Rates for the new property

Similar considerations apply to the decision whether to buy business premises or rent them: another key decision where the marginal tax rate may alter the outcome.

For full details of the capital allowances available, see the Taxcafe.co.uk guide *'Using a Property Company to Save Tax'*.

A less significant issue, but also far simpler, is the question of business entertaining versus sales discounts.

Example
Clarence, the owner/director of Nowtrig Ltd, usually throws an annual party for his biggest customers. It's a lavish affair and costs £10,000 each year. His finance director, Susan, often complains about the cost and says they could provide just as much incentive for their customers to stay loyal by offering sales discounts worth £12,500 per year.

"But that would cost more," said Clarence when they discussed the matter a few years ago.

"Yes, but we would get tax relief for sales discounts, which we don't get for business entertaining," replied Susan.

"But we only pay Corporation Tax at 19%, so the discounts would still cost £10,125, even after tax relief."

In 2023, Susan raises the subject again, "Now we have a marginal tax rate of 26.5%, so the discounts will only cost us £9,188 after tax relief, but your party will still cost £10,000."

"I don't care, I'm keeping the party," insists Clarence.

Again, there are other factors to consider!

3.9 CHANGING YOUR COMPANY'S ACCOUNTING DATE

You can change your company's accounting date fairly easily by submitting form AA01 to Companies House any time before the earlier of the filing deadline for the accounts based on its current accounting date and the filing deadline based on the revised accounting date you are requesting. Generally, for a private company, this means before the earlier of nine months from your old accounting date or nine months from your new accounting date.

Hence, for example, if you currently have a 31st December accounting date and you wish to change it to 31st March from 2023 onwards, you will have until 30th September 2023 to submit form AA01 to Companies House and make the change.

If you currently have a 30th June accounting date and you wish to change it to 31st March from 2023 onwards, you will have until 31st December 2023 to submit form AA01 to Companies House and make the change.

Slightly earlier filing deadlines usually apply to the company's first set of accounts, so watch out for those if your company is fairly new.

Having said all that, most companies make a fairly regular, steady level of profit all year, and each year, so there would usually be little point in changing your accounting date in an attempt to reduce the impact of the Corporation Tax increases.

Example
Oireabhal Ltd makes a monthly profit of £10,000 each month until December 2022. Its profits then increase to £10,500 per month in 2023 and £11,000 per month in 2024 and 2025.

If the company has a 31st December accounting date, its taxable profits and Corporation Tax liabilities will be as follows:

Year ending 31st December 2022: profit £120,000, Corporation Tax due £22,800
Year ending 31st December 2023: profit £126,000, Corporation Tax due £28,242 (see Section 2.7)
Year ending 31st December 2024: profit £132,000, Corporation Tax due £31,230
Three year total: £82,272

If we add a quarter of the Corporation Tax due for the year ending 31st December 2025, £7,808 (£31,230 x ¼), we get a total of £90,080 for the period from 1st January 2022 to 31st March 2025.

If the company has a 31st March accounting date, its taxable profits and Corporation Tax liabilities will be:

Year ending 31st March 2023: profit £121,500, Corporation Tax due £23,085
Year ending 31st March 2024: profit £127,500, Corporation Tax due £30,038
Year ending 31st March 2025: profit £132,000, Corporation Tax due £31,230
Three year total: £84,353

If we add a quarter of the Corporation Tax due for the year ending 31st March 2022, £5,700 (£120,000 x ¼ x 19%), we get a total of £90,053 for the period from 1st January 2022 to 31st March 2025.

As we can see, at fairly steady profit levels the company's accounting date makes very little difference to the overall, long-term tax liability over a comparable period. But, where it may be worth changing the company's accounting date is where an

exceptionally high level of profit is anticipated shortly before 31st March 2023. This could happen for a number of reasons, but one of the main causes could be a capital gain arising shortly before 31st March 2023.

Example Revisited

Oireabhal Ltd's regular monthly profits remain as before but, in addition, the company makes a capital gain of £400,000 in February 2023. Let us now suppose the company has a 31st December accounting date. Leaving things as they stand, its profits chargeable to Corporation Tax, and Corporation Tax liabilities will now be:

Year ending 31st December 2022: profit £120,000, Corporation Tax due £22,800
Year ending 31st December 2023: profit £526,000, Corporation Tax due £123,720 (see Section 2.7)
Year ending 31st December 2024: profit £132,000, Corporation Tax due £31,230
Three year total: £177,750

If we add a quarter of the Corporation Tax due for the year ending 31st December 2025, £7,808 (£31,230 x ¼), we now get a total of £185,558 for the period from 1st January 2022 to 31st March 2025.

Instead, however, Oireabhal Ltd changes its accounting date to 31st March and draws up accounts for the fifteen month period ending 31st March 2023. This changes the company's profits chargeable to Corporation Tax, and Corporation Tax liabilities to the following:

Period ending 31st March 2023: profit £551,500, Corporation Tax due £104,785
Year ending 31st March 2024: profit £127,500, Corporation Tax due £30,038
Year ending 31st March 2025: profit £132,000, Corporation Tax due £31,230

The total Corporation Tax due for the period from 1st January 2022 to 31st March 2025 is now £166,053.

The company has saved almost £20,000 simply by changing its accounting date!

Later Changes

A change of accounting date could even save tax on exceptional profit 'spikes' after the Corporation Tax increase takes effect on 1st April 2023.

Example

Aonach Limited is a trading company with a 31st March accounting date. It makes a steady monthly profit of £10,000. In May 2023, it receives an exceptional windfall adding an additional £100,000 to its profit for the month.

As things stand, the windfall profit will be taxed at an effective rate of 26.5%, adding £26,500 to Aonach Limited's Corporation Tax bill for the year ending 31st March 2024.

Alternatively, if the company changes its accounting date and draws up accounts for the fourteen months ending 31st May 2023, its total profit for the period will be £240,000. This can be allocated on a pro rata basis (see Section 2.2) with 12/14ths falling into the twelve months ending 31st March 2023 and being taxed at a flat rate of 19%. The other 2/14ths falls into the two month period ending 31st May 2023 and is taxed at the new Corporation Tax rates.

More importantly though, the effect of all this is that 12/14ths of the windfall profit received in May 2023 is taxed at 19%, with only 2/14ths effectively being taxed at the new marginal rate of 26.5%.

The overall tax rate on the windfall profit thus equates to 20.071%, saving the company £6,429.

Extending the company's accounting period in the manner described above will save tax on windfall trading profits, but will not help to reduce the Corporation Tax on capital gains arising after 31st March 2023 since, where there is a long accounting period of more than twelve months, these must be allocated to the period in which they arise. However, shortening the company's accounting period may sometimes help to save tax on a capital gain arising after 31st March 2023.

Example

Cairn Toul Limited makes a regular annual profit of £100,000 and draws up accounts to 31st December each year. In June 2023 it makes a

capital gain of £500,000. As things stand, the capital gain will effectively give rise to additional Corporation Tax of £119,292 (£149,317 x 24.651% + £350,683 x 23.521%: see Section 2.7 and Appendix A).

Alternatively, if the company draws up accounts for the six months ending 30th June 2023, it will have total profits chargeable to Corporation Tax for the period of £550,000, which will be split as follows:

2022 Financial Year: £550,000 x 90/181 = £273,481
2023 Financial Year: £550,000 x 91/181 = £276,519

The lower limit for the element of profits falling into the 2023 Financial Year will be £12,432 (£50,000 x 91/366) and the upper limit will be £62,159 (£250,000 x 91/366). The company will therefore effectively be taxed as follows:

Trading Profits
2022 Financial Year: £50,000 x 90/181 = £24,862 @ 19% = £4,724
2023 Financial Year: £50,000 x 91/181 = £25,138

	£12,432 @ 19%	= £2,362
	£12,706 @ 26.5%	= £3,367
Total		£10,453

The £25,138 of trading profits falling into the 2023 Financial Year effectively leaves £37,021 (£62,159 − £25,138) of the company's marginal rate band for the period available.

Capital Gain
2022 Financial Year: £500,000x90/181= £248,619 @ 19% = £47,238
2023 Financial Year: £500,000x91/181= £251,381

	£37,021 @ 26.5%	= £3,367
	£214,360 @ 25%	= £53,590
Total		£104,195

Following the conclusion we were able to draw after the first part of our first example in this section, it is fair to say that Cairn Toul Limited's regular trading profits are effectively suffering the same amount of Corporation Tax regardless of the change in the company's accounting date.

However, the tax suffered on the capital gain has reduced from £119,292 to £104,195, generating a saving of £15,097. Once again this has been achieved simply by changing the company's accounting date!

3.10 SEASONAL BUSINESSES

In Section 3.9, we looked at the potential benefits of companies changing their accounting date where they were making capital gains or exceptional windfall profits either shortly before, or shortly after, 31st March 2023.

Another area worth considering is companies with seasonal businesses where the profits do not arise evenly over the course of the year. For example:

- Retailers often make greater profits in November/December
- The wholesalers that supply them make greater profits in September/October
- Businesses in the tourism sector may make greater profits in the summer months...
- Except in winter resorts where most profit arises between Christmas and Easter
- Farming businesses often make most profit around harvest time: although that may shift slightly depending on the weather
- Car dealers often make most profit in March and September
- Accountants specialising in personal tax work may make most of their profit in January

Many companies with seasonal businesses could make Corporation Tax savings by changing their accounting date, although this depends on both when their 'season' is and their current accounting date.

If the current accounting date is shortly before the most profitable season, extending the accounting period ending during 2022, or early 2023 can lead to an effective deferral of the impact of the Corporation Tax increases.

Example

Cairnwell Limited makes a profit of around £250,000 between January and March each year. It breaks even between April and December. Currently, the company draws up accounts to 31st December.

As things stand, the profits of its 2023 season will suffer Corporation Tax at an effective rate of 23.521% (see Appendix A); and its 2024 season will be taxed at 25%.

However, if the company draws up accounts for the fifteen month period ending 31st March 2023 and adopts a 31st March accounting date thereafter, the profits of its 2023 season will be taxed at 19%. Its 2024 season will be taxed at 25% as before.

The change of accounting date will therefore save the company 4.521% on its 2023 season profits, or £11,303.

Where the current accounting date is shortly after the most profitable season, however, an extended accounting period straddling 1st April 2023 would increase the company's Corporation Tax bill.

Example

Blencathra Limited makes a profit of around £600,000 each year between May and September. It breaks even over the rest of the year and currently has a 30th September accounting date.

As things stand, the profits of its 2023 season will suffer Corporation Tax at an effective rate of 22.008% (see Appendix A); and its 2024 season will be taxed at 25%.

Alternatively, if the company were to draw up accounts for the eighteen month period ending 31st March 2024 and adopt a 31st March accounting date thereafter, the profits of its 2023 season would be divided pro rata. £400,000 would fall into the twelve months ending 30th September 2023 and be taxed at 22.008% as before, while £200,000 would fall into the six month period ending 31st March 2024 and be taxed at 25%. This would cost the company an extra £5,984.

Where such a company's profits are at a lower level, however (less than £375,000), extending the following year's accounting period may lead to modest Corporation Tax savings.

Example Continued

Blencathra Limited wisely kept its 30th September accounting date in
2023 but it has a poor season in 2024 and only makes a profit of
£240,000. As things stand, this will be taxed as follows:

£50,000 x 19% = *£9,500*
£190,000 x 26.5% = *£50,350*
Total *£59,850*

Instead, however, the company draws up accounts for the eighteen
months ending 31st March 2025. These show the same £240,000 profit
(as the company breaks even between October and March) but it will
now be taxed as follows:

Twelve Months Ending 30th September 2024

Taxable profit £240,000 x 12/18 = £160,000
Taxed at:
£50,000 x 19% = *£9,500*
£110,000 x 26.5% = *£29,150*
Total *£38,650*

Six Months Ending 31st March 2025

Taxable profit £240,000 x 6/18 = £80,000
Taxed at:
£24,932 x 19% =* *£4,737*
£55,068 x 26.5% = *£14,593*
Total *£19,330*

Total for eighteen month period = £57,980

** Lower limit for six month period ending 31st March 2025: £50,000 x*
182/365

As we can see, extending the accounting period after the
Corporation Tax increases have been fully implemented has led to
a saving of £1,870 (£59,850 – £57,980). It's not as good as some of
the savings we have seen over the last two sections but, as a well-
known retailer often says, 'every little helps'; and the only cost of
doing it is submitting a form AA01 and completing an extra
Corporation Tax Return.

Chapter 4

The Super-Deduction and Other Capital Allowances Planning Issues

4.1 THE BIGGER PICTURE

In the March 2021 Budget, former Chancellor Rishi Sunak announced the introduction of a 130% super-deduction for qualifying purchases of new plant and machinery, and a 50% first year allowance for certain other expenditure on new assets.

These temporary additional capital allowances provide some exciting opportunities to make major tax savings and we will be covering them in detail in this chapter.

However, it is also important to understand how the super-deduction and 50% first year allowance fit alongside other capital allowances available on plant and machinery, as well as the other Corporation Tax changes we have looked at already.

Hence, we will also look at the existing capital allowances regime and, in particular, the part it has to play in marginal rate tax planning. While, in many cases, the super-deduction will provide valuable additional tax savings, we will also discover that, in some cases, it is of little or no benefit.

We also need to understand what plant and machinery is. We will cover that in Sections 4.5 and 4.6.

4.2 THE SUPER-DEDUCTION

Companies (and only companies) purchasing new qualifying plant and machinery between 1st April 2021 and 31st March 2023 are eligible for a super-deduction of 130% of their qualifying expenditure.

Subject to the exclusions set out below, the super-deduction is available on new qualifying plant and machinery that would otherwise fall into the main pool (see Sections 4.5, 4.6, and 4.10

for further details and examples of the types of expenditure that qualify).

Expenditure during the same period on new qualifying plant and machinery that would fall into the special rate pool is eligible for a first year allowance of 50%. We will look at this allowance, and the types of expenditure it applies to, in Section 4.11.

Unlike the annual investment allowance (Section 4.7), the super-deduction is not subject to any annual limit. Nor is it restricted if the company draws up accounts for a period of less than twelve months. There are, however, transitional rules for companies with accounting periods straddling 31st March 2023. Furthermore, the super-deduction is subject to a number of conditions and exclusions. We will examine these issues later, but first, in this section, we will focus on the impact of the super-deduction on a company's taxable profits and, more importantly, its Corporation Tax bill.

Note that, throughout this section, and most of this chapter, we will be looking purely at the tax consequences of your company's capital expenditure. In practice, commercial considerations should generally take precedence. We will look at some of the practical issues to consider in Section 4.20.

Nonetheless, it remains a fact that small timing differences will sometimes make a big difference to your Corporation Tax bill: and that in itself may sometimes make the most sense commercially.

The super-deduction is effectively designed to provide larger companies, with annual profits in excess of £250,000, with approximately the same Corporation Tax saving as an investment in new plant and machinery that would otherwise be covered by the annual investment allowance if made in a later period, when the main rate of Corporation Tax has increased to 25% (130% x 19% = 24.7%: a close approximation to the main rate of Corporation Tax applying after 31st March 2023).

In other words, the Government is trying to stop large companies delaying investment in plant and machinery in order to obtain more Corporation Tax relief.

We will return to larger companies later, but it makes sense for us to start with the impact on small companies first. Note that, for

small and medium-sized companies, I am assuming any expenditure not covered by the super-deduction will be covered by the annual investment allowance.

We will look at the annual investment allowance in detail in Section 4.7, but the good news is the maximum allowance available is now set to remain at £1m for the foreseeable future.

When we move on to larger companies, with annual profits in excess of £250,000, I will start to look at situations where expenditure exceeds the maximum annual investment allowance. In the rare instance that a company with annual profits less than £250,000 spends in excess of the annual investment allowance, similar considerations will apply.

Critical Caution

Because the super-deduction is subject to transitional rules for accounting periods straddling 31st March 2023, the analysis and conclusions set out below, in the rest of this section, are for companies with a 31st March accounting date *only*.

We will look at the position for companies with other accounting dates in Section 4.3.

Small Companies

As we saw in Chapter 2, companies with annual profits not exceeding £50,000 will see no change in their Corporation Tax rate after 31st March 2023. Hence, the super-deduction simply provides additional tax relief and it will make sense for small companies that will continue to pay Corporation Tax at 19% to accelerate expenditure qualifying for the super-deduction to before 31st March 2023 to obtain tax relief at an effective rate of 24.7%.

Example

Reza runs his small trading business through his company, Sanda Ltd. The company makes profits of between £40,000 and £50,000 each year and has a 31st March accounting date. Reza is planning to buy a new piece of machinery at a cost of £10,000. If he buys it before 31st March 2023, Sanda Ltd will save £2,470 in Corporation Tax (£10,000 x 130% x 19%). If Reza buys the machine later, and claims the annual investment allowance, the company will only save £1,900 (£10,000 x 19%).

The conclusion seems fairly obvious: small companies should buy items qualifying for the super-deduction before 31st March 2023.

However, in some cases, the company may be expecting its annual profits to increase above £50,000, so that it will start to pay Corporation Tax at a marginal rate of 26.5% in the future (see Section 2.3). We will look at that situation next.

Medium-Sized Companies

As we saw in Chapter 2, companies with annual profits between £50,000 and £250,000 will be facing a marginal Corporation Tax rate of 26.5% after March 2023. What does this mean for the value of the super-deduction?

Example
Anne runs a mobile catering business through her company, Ruberslaw Ltd. The company has a 31st March accounting date and makes annual profits of between £80,000 and £100,000. Anne wants to buy a new van at a cost of £25,000. If she buys the van before 31st March 2023, Ruberslaw Ltd will be eligible for the super-deduction, giving it a Corporation Tax saving of £25,000 x 130% x 19% = £6,175.

Alternatively, if Anne delays the purchase of the new van until after March 2023, Ruberslaw Ltd will enjoy a Corporation Tax saving of £25,000 x 26.5% = £6,625.

Delaying the purchase will therefore save the company an extra £450, or 1.8% of the cost of the van.

As we can see, medium-sized companies with annual profits between £50,000 and £250,000 and a 31st March accounting date will be better off delaying the purchase of new plant and machinery until after 31st March 2023.

However, while a saving of just 1.8% might be worth a small delay in the purchase of new qualifying plant and machinery, it will seldom justify a major delay that might have significant commercial repercussions.

Those companies with annual profits that are currently below £50,000, but which might exceed £50,000 in the near future face a bit of a dilemma. Accelerating expenditure to before 31st March 2023 in order to obtain the super-deduction will save an extra

5.7% if, in fact, their profits do not exceed £50,000 in the end; but deferring the expenditure until after 31st March 2023 may save a further 1.8% on top of that if their profits do increase above £50,000.

If in doubt, I would tend to say it makes more sense to go for the super-deduction and secure the 5.7% saving, rather than hold out for the chance of an extra 1.8%. If you get it wrong, you still effectively keep the 5.7% saving; you just don't get a further 1.8%. In the end, it really depends how sure you are of your future profit levels: as well as those all-important commercial considerations.

For expenditure not qualifying for the super-deduction (e.g. second-hand assets), companies with annual profits between £50,000 and £250,000 will generally be better off delaying the expenditure until they have a 26.5% marginal Corporation Tax rate. Assuming the expenditure is covered by the annual investment allowance, this will produce the same savings as deferring other types of spending we saw in Sections 3.1 and 3.2.

Larger Companies

The way the super-deduction has been designed, the position is inevitably pretty borderline for companies with annual profits in excess of £250,000, but which will not be spending in excess of the maximum annual investment allowance. As we know, these companies will be paying Corporation Tax at the main rate of 25% after 31st March 2023.

Example
Pillar Ltd makes annual profits of around £2.5m and is planning to invest in some new machinery costing £500,000 in the near future. The company has a 31st March accounting date. If it purchases the machinery before 31st March 2023, it will be eligible for the super-deduction and hence will be able to claim a deduction from its profits chargeable to Corporation Tax of: £500,000 x 130% = £650,000. The £650,000 deduction will save the company £123,500 in Corporation Tax (£650,000 x 19%).

If, on the other hand, Pillar Ltd buys the machinery after 31st March 2023, it will simply claim the annual investment allowance (Section 4.7), giving it tax relief for its £500,000 of expenditure. Its Corporation Tax rate will then be 25%, so this saves the company £125,000 in Corporation Tax (£500,000 x 25%).

As we can see, for larger companies with a 31st March accounting date, there is no incentive to accelerate expenditure that would be covered by the annual investment allowance in any case, simply in order to obtain the super-deduction.

In fact, in this scenario, the company would actually be slightly better off delaying its purchases until after 31st March 2023. However, with a tax saving equal to just 0.3% of the expenditure, it would be best to buy the machinery when it makes most sense from a commercial perspective.

Companies with annual profits that are currently between £50,000 and £250,000, but which might exceed £250,000 in the near future, do not face the same kind of dilemma as the smaller companies we looked at earlier. For these growing, medium-sized companies, delaying the expenditure until after 31st March 2023 will produce the best tax savings whether their profits do, in fact, exceed £250,000 in the end, or not. If profits remain below £250,000, the saving is 1.8%; if profits exceed £250,000, the saving is 0.3%.

Either way, the savings are generally too small to override commercial considerations. The only thing a company with a 31st March accounting date really needs to be wary of is any risk that its profits might fall below £50,000: in which case, as we saw above, it would be better off accelerating the expenditure and claiming the super-deduction.

Big Spenders

So far, I've assumed any expenditure delayed until after 31st March 2023 will be covered by the annual investment allowance. The position changes where the company is planning to spend in excess of the maximum available annual investment allowance, which we expect to remain at £1m for the foreseeable future.

Example Revisited
Pillar Ltd revises its plans and now intends to spend £1.5m on new machinery. If it purchases the machinery before 31st March 2023, its super-deduction will amount to £1.95m (£1.5m x 130%), saving the company £370,500 in Corporation Tax (£1.95m x 19%).

If Pillar Ltd delays its expenditure until after 31st March 2023, however, it will only be eligible for an annual investment allowance of £1m.

The remaining £500,000 of expenditure will attract a writing down allowance of 18%. Hence, Pillar Ltd's total capital allowances claim would be £1.09m saving it £272,500 (£1.09m x 25%) in Corporation Tax.

We can now see that, where expenditure in excess of the annual investment allowance is planned, the super-deduction will provide much greater Corporation Tax savings. Admittedly, in our example, Pillar Ltd would be able to continue claiming writing down allowances of 18% on the unrelieved £410,000 of its post-31st March 2023 spend in future years, but it would take many years to achieve the same Corporation Tax saving as would have been provided by the super-deduction (up to seventeen years, in fact, assuming no changes to Corporation Tax or the capital allowances regime).

Hence, companies planning to spend in excess of the annual investment allowance will be better off if they accelerate expenditure qualifying for the super-deduction so that it takes place by 31st March 2023. This applies not just to those spending in excess of £1m on items that would qualify for the super-deduction, but to any company spending in excess of £1m on items that would qualify for the annual investment allowance (which is subject to fewer exclusions: see Section 4.7).

Example
Quinag Ltd is planning to spend £750,000 on new qualifying plant and machinery plus £500,000 on second-hand plant and machinery that will not qualify for the super-deduction, but will qualify for the annual investment allowance. The company has a 31st March accounting date and makes annual profits of over £2m.

Scenario 1: *Make all the purchases in the year ending 31st March 2023*
The company gets a super-deduction of £975,000 (£750,000 x 130%) plus an annual investment allowance of £500,000. A total of £1.475m is available for Corporation Tax relief, providing a saving of £280,250 (£1.475m x 19%).

Scenario 2: *Make all the purchases in the year ending 31st March 2024*
The company gets a maximum annual investment allowance of £1m plus writing down allowances of £45,000 (£250,000 x 18%). A total of £1.045m is available for Corporation Tax relief, providing a saving of

£261,250 (£1.045m x 25%). Further writing down allowances will be available in future years, but it will take four years to achieve the same saving as under Scenario 1.

Scenario 3: *Purchase the items qualifying for the super-deduction in the year ending 31st March 2023; and the items not qualifying for the super-deduction in the year ending 31st March 2024*
The company gets a super-deduction of £975,000 (£750,000 x 130%) in the year ending 31st March 2023; and an annual investment allowance of £500,000 in the year ending 31st March 2024. The total Corporation Tax saving produced over the two years is £310,250 (£975,000 x 19% + £500,000 x 25%).

(If you're interested, it will take up to seventeen years to achieve the same saving under Scenario 2 as under Scenario 3)

In conclusion, where the total expenditure eligible for the annual investment allowance exceeds the maximum of £1m, it is generally better to accelerate the expenditure eligible for the super-deduction to before 31st March 2023, but defer the expenditure not eligible for the super-deduction until after 31st March 2023.

Scenario 3 can be improved upon slightly but, in practice, it is probably not worth pursuing a small additional saving that can probably only be achieved if you know exactly how much you are going to spend on qualifying plant and machinery in each of two successive accounting periods. However, for the purists among you, here is the optimum scenario for Quinag Ltd:

Scenario 4: *Spend £250,000 on items qualifying for the super-deduction in the year ending 31st March 2023; and purchase the remaining items in the year ending 31st March 2024*

The company gets a super-deduction of £325,000 (£250,000 x 130%) in the year ending 31st March 2023; and an annual investment allowance of £1m in the year ending 31st March 2024. The total Corporation Tax saving produced over the two years is £311,750 (£325,000 x 19% + £1m x 25%).

If you can plan your expenditure with this degree of precision, this optimum scenario saves an additional £1,500 (compared with Scenario 3). However, if Quinag Ltd were to purchase any further plant and machinery during the year ending 31st March 2024, it would only qualify for writing down allowances at 18%

(sometimes 6%) and the company would thus be worse off than under Scenario 3. Hence, in reality, I would not recommend chasing this small additional saving unless you can be absolutely certain of your plant and machinery expenditure.

Regular Big Spenders

Companies that spend in excess of the maximum annual investment allowance every year will generate the greatest Corporation Tax savings by accelerating any expenditure qualifying for the super-deduction to before 31st March 2023. These large companies will also benefit by timing any expenditure that qualifies for the annual investment allowance but not the super-deduction so that as much as possible is covered by the annual investment allowance.

Example

Ciste Dhubh Ltd is a large manufacturing company with a 31st March year end. It is planning to spend £4m on qualifying plant and machinery between now and 31st March 2024. £2.5m of this expenditure will qualify for the super-deduction. The optimum strategy for Ciste Dhubh Ltd is:

i) Purchase items qualifying for the super-deduction by 31st March 2023
ii) Spend a further £500,000 on items qualifying for the annual investment allowance by 31st March 2023
iii) Spend the remaining £1m by 31st March 2024

This produces savings of:
£2.5m x 130% x 19% £617,500
£500,000 x 19% £95,000
£1m x 25% £250,000
Total £962,500

In practice, it might make sense to spend a little more during the year ending 31st March 2023, to avoid the risk that additional expenditure in the following year will only attract writing down allowances at 18% or 6%.

Summary

In brief, in most cases for companies with a 31st March accounting date, where expenditure would qualify for the super-deduction if it were made by 31st March 2023, the position from a tax perspective can be summarised as follows:

Small companies with annual profits not exceeding £50,000: make purchases by 31st March 2023 to produce a saving of 5.7%.

Medium-sized companies with annual profits between £50,000 and £250,000: deferring purchases until after 31st March 2023 will produce a modest saving of 1.8%.

Larger companies with annual profits in excess of £250,000, but which are spending less than £1m on qualifying plant and machinery: the position is extremely borderline; with a saving of 0.3% arising if purchases are deferred until after 31st March 2023.

Large companies with annual profits in excess of £250,000, and which are spending more than £1m on qualifying plant and machinery: make purchases of assets qualifying for the super-deduction by 31st March 2023 to produce considerable Corporation Tax savings.

All this is, of course, subject to commercial considerations.

Companies that do not have a 31st March accounting date will be subject to transitional rules for both the super-deduction and Corporation Tax in the period straddling 31st March 2023. In the next section, we will look at the transitional rules for the super-deduction and assess their impact on these companies.

4.3 TRANSITIONAL RULES FOR SUPER-DEDUCTION

Firstly, it is worth mentioning there are no transitional rules for accounting periods straddling 1st April 2021, when the super-deduction began. As long as the expenditure took place after 31st March 2021, the super-deduction is available (subject to the conditions and exclusions we will examine in Section 4.4).

However, there are transitional rules for accounting periods straddling the end of the super-deduction on 31st March 2023.

This is because the Government is broadly trying to maintain the effective Corporation Tax saving for investment in new plant and machinery at around 25% for companies with annual profits in excess of £250,000, whatever their accounting date may be.

Hence, the super-deduction is reduced where the accounting period straddles 31st March 2023. For example, the super-deduction for expenditure incurred between 1st January and 31st March 2023 by a company with a twelve month accounting period ending 31st December 2023 is:

$$30\% \times 90/365 = 7.4\% + 100\% = 107.4\%$$

BUT, critically, the super-deduction only remains available on expenditure incurred by 31st March 2023, regardless of when the company's accounting period ends.

As we saw in Section 2.7, companies with accounting periods straddling 31st March 2023 are also subject to transitional rules to determine the rate of Corporation Tax applying to the period. These rules create the effective marginal Corporation Tax rates set out in Appendix A.

Hence, for example, a company with profits between £49,863 and £249,317 (see Section 2.7) for the twelve month accounting period ending 31st December 2023 has a marginal Corporation Tax rate of 24.651%.

If this company purchases assets qualifying for the super-deduction between 1st January and 31st March 2023, this will produce a tax saving of

$$107.4\% \times 24.651\% = 26.475\%$$

Following the same principles, we can derive the overall tax saving percentages for expenditure incurred:

- During a twelve month accounting period that straddles 31st March 2023, but
- No later than 31st March 2023
- By companies with different marginal Corporation Tax rates (see Section 2.7 and Appendix A)

These, together with the relevant super-deduction percentages are set out in the table below. The years ending 31ˢᵗ March 2023 and 31ˢᵗ March 2024 are included for comparison.

Super-Deduction Tax Savings

Year Ending:	Super-Dedctn	Saving For Companies Paying Corporation Tax At:		
		Small Profits Rate	Marginal Rate	Main Rate
31-Mar-2023	130.00%	24.700%	24.700%	24.700%
30-Apr-2023	127.53%	24.232%	25.018%	24.860%
31-May-2023	124.99%	23.747%	25.314%	25.001%
30-Jun-2023	122.52%	23.279%	25.570%	25.112%
31-Jul-2023	119.97%	22.795%	25.802%	25.201%
31-Aug-2023	117.42%	22.311%	26.002%	25.264%
30-Sep-2023	114.96%	21.842%	26.165%	25.300%
31-Oct-2023	112.41%	21.358%	26.301%	25.312%
30-Nov-2023	109.95%	20.890%	26.402%	25.299%
31-Dec-2023	107.40%	20.405%	26.474%	25.260%
31-Jan-2024	104.85%	19.921%	26.514%	25.195%
29-Feb-2024	102.54%	19.483%	26.522%	25.114%
31-Mar-2024	n/a	19.000%	26.500%	25.000%

One thing we can quickly conclude for companies with profits at all levels is that, if you are going to incur expenditure eligible for the super-deduction during an accounting period that straddles 31ˢᵗ March 2023, you will always benefit from a greater tax saving if you ensure the expenditure is incurred by that date.

In the analysis that follows, I have again assumed that all expenditure incurred by small or medium-sized companies will be covered by the annual investment allowance. Only when we move on to larger companies will I also consider the position where the company's expenditure exceeds the annual investment allowance. Nonetheless, should any small or medium-sized companies spend in excess of the maximum available annual investment allowance, similar considerations will apply (although this now seems highly unlikely given that the annual investment allowance is expected to remain at £1m indefinitely).

So, subject to the above points, what do the transitional rules for the super-deduction mean for companies with different levels of annual profits and expenditure on plant and machinery?

Small Companies

Companies with annual profits not exceeding £50,000 will save the most tax by purchasing items eligible for the super-deduction in an accounting period that ends before 31st March 2023. The next best option is to make the purchases during the accounting period that straddles 31st March 2023, but before that date.

Medium-Sized Companies

For companies with annual profits between £50,000 and £250,000, the main thing to **avoid** in some cases is purchasing items that would otherwise be eligible for the super-deduction after 31st March 2023, but before the company's next accounting date thereafter. The relevant rate of tax saving for expenditure in this period (assuming it is covered by the annual investment allowance) is as shown in Appendix A (under 'Marginal Relief').

This is particularly relevant for accounting periods ending shortly after 31st March 2023, as the reduction in the tax saving is greater.

For example, a company with a twelve month accounting period ending on 30th April 2023 would obtain a tax saving of just 19.616% on qualifying expenditure incurred during the month of April 2023. This compares with 24.7% on expenditure incurred before 30th April 2022; 25.018% on expenditure incurred between 1st May 2022 and 31st March 2023; and 26.5% on expenditure incurred after 30th April 2023.

However, the impact on companies with accounting dates later in the Financial Year (see Section 1.2) is less significant.

For example, a company with a twelve month accounting period ending on 31st December 2023 could obtain a tax saving of 24.651% on qualifying expenditure incurred between 1st April and 31st December 2023. This is not significantly different to the saving of 24.7% on expenditure incurred before 31st December 2022; 26.474% on expenditure incurred between 1st January and 31st March 2023; and 26.5% on expenditure incurred after 31st December 2023.

To summarise, the position for expenditure qualifying for the super-deduction, or which would otherwise be covered by the annual investment allowance, incurred by companies with annual profits between £50,000 and £250,000, is that the company will enjoy an overall tax saving at:

- 24.7% if it incurs the expenditure in an accounting period ending before 31st March 2023
- The rate given in the table above (under 'Marginal Rate') if it incurs the expenditure in an accounting period straddling 31st March 2023, but before that date
- The rate given in Appendix A (under 'Marginal Rate') if it incurs the expenditure in an accounting period straddling 31st March 2023, but after that date
- 26.5% if it incurs the expenditure in an accounting period commencing after 31st March 2023

Apart from expenditure incurred after 31st March 2023 during accounting periods ending between April and November 2023, the difference in the overall tax saving is never more than 2%, and hence not really enough to warrant concern.

One quirk worth noting though is that the best tax savings are created by expenditure incurred during accounting periods ending in January or February 2024, but before 31st March 2023.

As in Section 4.2, all this is based on the assumption that the expenditure will be covered by the annual investment allowance if it does not attract the super-deduction.

Larger Companies

For companies with annual profits in excess of £250,000, but which are not spending in excess of the maximum annual investment allowance, the position is very similar to the position for medium-sized companies, but the variation in the overall rate of tax saving is even less.

The position for expenditure qualifying for the super-deduction, or which would otherwise be covered by the annual investment allowance, incurred by companies with annual profits in excess of £250,000, is that the company will enjoy an overall tax saving at:

- 24.7% if it incurs the expenditure in an accounting period ending before 31st March 2023
- The rate given in the table above (under 'Main Rate') if it incurs the expenditure in an accounting period straddling 31st March 2023, but before that date
- The rate given in Appendix A (under 'Main Rate') if it incurs the expenditure in an accounting period straddling 31st March 2023, but after that date
- 25% if it incurs the expenditure in an accounting period commencing after 31st March 2023

Once again, the only differences of more than 2% in the overall tax saving are for expenditure incurred after 31st March 2023 during accounting periods ending between April and November 2023. Hence, apart from these cases, the differences are generally too small to warrant any concern.

The quirk worth noting this time is that the best tax savings are created by expenditure incurred during accounting periods ending between May 2023 and February 2024, but before 31st March 2023. The best saving of all (25.312%) is to incur expenditure during an accounting period ending 31st October 2023, but before 31st March 2023.

As before, all this is based on the assumption that the expenditure will be covered by the annual investment allowance if it does not attract the super-deduction.

Big Spenders

Where the company is incurring expenditure in excess of the annual investment allowance, it will always make sense to endeavour to incur the expenditure by 31st March 2023 in order to obtain the super-deduction. A super-deduction of 107.4%, 102.54%, or, in fact, anything over 100% will always be better than writing down allowances at 18%.

The best tax savings are created by incurring expenditure during an accounting period that straddles 31st March 2023, but before that date.

Summary

In most cases where expenditure would qualify for the super-deduction if it were made by 31st March 2023, the position from a tax perspective for companies that do not have a 31st March accounting date can be summarised as set out below.

Companies of all sizes: make purchases by 31st March 2023 if the expenditure would not be covered by the annual investment allowance if it were made later.

Subject to this:

Small companies with annual profits not exceeding £50,000: make purchases by your last accounting date before 31st March 2023 to produce the best saving of 5.7%. Failing that, smaller savings are available, provided the purchase is made by 31st March 2023.

Medium-sized companies with annual profits between £50,000 and £250,000: the timing of purchases generally makes little difference, but purchases between 1st April 2023 and an accounting date any time between April and November 2023 should generally be avoided.

Larger companies with annual profits in excess of £250,000, but which are spending less than the maximum available annual investment allowance on qualifying plant and machinery: the timing of purchases generally makes little difference, but purchases between 1st April 2023 and an accounting date any time between April and November 2023 should generally be avoided.

Large companies with annual profits in excess of £250,000, and which are spending more than the maximum available annual investment allowance on qualifying plant and machinery: make purchases of assets qualifying for the super-deduction by 31st March 2023 to produce considerable Corporation Tax savings. The best savings are produced when expenditure is incurred during an accounting period straddling 31st March 2023, but before that date.

As usual, all of this is subject to commercial considerations.

4.4 CONDITIONS AND EXCLUSIONS

The first condition applying to both the super-deduction and the 50% first year allowance (see Section 4.11) is that they are only available to companies. The next, highly restrictive, condition applying to both allowances is that they are only available on new assets. Used and second-hand assets are not eligible for either. This is just one of a number of exclusions, as listed below.

Exclusions

The following assets are not eligible for either the 130% super-deduction or the 50% first year allowance:

- Cars (see Section 4.15)
- Used and second-hand assets
- Assets held for leasing (see further below regarding assets in rental property)
- Acquisitions during the accounting period when the qualifying activity ceases
- Gifted assets or other transfers from a connected person
- Assets acquired under contracts entered into before 3rd March 2021
- Ships
- Railway assets
- Expenditure of £100,000 or more on plant and machinery with an anticipated working life of 25 years or more (long life assets)
- Assets acquired for use wholly or partly in a 'ring-fence' trade in the oil and gas industry (these get their own 100% allowances under a different relief)
- Assets acquired as part of arrangements which are contrived, abnormal, or lacking genuine commercial purpose

A lot of these can be described as 'the usual suspects' and were probably to be expected. Cars, for example, are also excluded from the annual investment allowance and effectively have their own capital allowances regime. We will look at capital allowances on company cars in Section 4.15.

Rental Property

Fortunately, most fixtures and fittings within rental property are excluded from the definition of 'assets held for leasing' for the purposes of both the 130% super-deduction and the 50% first year allowance. This means landlord companies renting out commercial property or furnished holiday lets will be able to claim these allowances on most new fixtures and fittings purchased by 31st March 2023.

The allowances will also be available to a landlord company renting out residential property on any new qualifying fixtures and fittings within communal areas outside any individual dwelling (e.g. the communal areas within a property divided into self-contained flats).

This includes 'integral features' (see Section 4.6), although these will only attract the 50% first year allowance and not the super-deduction.

However, the exemption for fixtures and fittings in rental property only covers items that are affixed to, or otherwise installed in, the property, and does not cover movable items.

Hence, landlord companies will not be able to claim the super-deduction on most furniture and free-standing, movable equipment within rental properties.

'Special Rate Assets'

In addition to the above exclusions, it is important to remember that assets which would otherwise fall into the 'special rate pool' do not qualify for the super-deduction but are eligible for the 50% first year allowance instead. We will look at what falls into the special rate pool in Section 4.10. We will then cover the 50% first year allowance in Section 4.11.

4.5 WHAT IS PLANT AND MACHINERY?

It is tempting to say that if it's a tangible asset and it isn't land, a building, or a car, then it is plant and machinery. That's not totally accurate, but it's a good starting point.

Plant and machinery includes the following items:

- Motor vehicles, including vans and motorcycles (technically, cars are also included, but they are treated differently for capital allowances purposes, as we shall see in Section 4.15)
- Ships, aircraft, spacecraft, satellites, locomotives and carriages
- Tools, machinery and equipment
- Computers and associated equipment such as printers, etc.
- Mobile phones, tablets, and other similar devices
- Software
- Furniture and moveable furnishings
- Caravans and mobile homes (when let out as holiday accommodation)
- Fixtures and fittings: there is a defined list of items affixed to buildings or structures that qualify as plant and machinery. We will cover this in detail in Section 4.6.

Plant and Machinery NOT Qualifying for Capital Allowances

Just because something is plant and machinery, doesn't necessarily mean it qualifies for capital allowances. These are some of the important exclusions to be aware of:

- Companies renting out residential property cannot claim capital allowances on assets within a rented residential dwelling (this does not apply to furnished holiday lets or assets in communal areas outside any individual dwelling)
- Caravans and mobile homes do not qualify for capital allowances if they are not being rented out as holiday accommodation
- Decorative assets (paintings, sculptures, etc) only qualify for capital allowances where provided for public enjoyment in hotels, restaurants and similar establishments

In general, an asset can only qualify for capital allowances if it is being used for the purpose of a qualifying business activity.

What Allowances are Available?

Apart from the super-deduction, the most important allowance for companies purchasing plant and machinery is the annual investment allowance and we will look at this in Section 4.7. Other allowances for plant and machinery include enhanced capital allowances and writing down allowances, and we will look at these in Sections 4.9 and 4.10 respectively.

4.6 FIXTURES, FITTINGS, AND OTHER ASSETS WITHIN PROPERTY

Assets within commercial property, qualifying furnished holiday lets, and communal areas within a rented residential property, but outside any individual dwelling, that qualify as plant and machinery for capital allowances purposes include:

- Integral features (see below)
- Manufacturing or processing equipment
- Furniture, furnishings, white goods, sinks, baths, showers and sanitary ware
- Sound insulation and gas or sewerage systems provided to meet the special requirements of a qualifying trading activity
- Storage or display equipment, counters and checkouts, cold stores, refrigeration and cooling equipment
- Computer, telecommunication and surveillance systems, including wiring and other links
- Fire and burglar alarms, sprinklers and fire-fighting equipment
- Strong rooms and safes
- Moveable partitioning where intended to be moved in the course of a qualifying trading activity
- Decorative assets provided for public enjoyment in hotels, restaurants and similar trades
- Advertising hoardings, signs and displays

Expenditure on the alteration of a building for the purpose of installing qualifying plant and machinery also qualifies for plant and machinery allowances itself.

Qualifying assets within property are usually eligible for the same rate of capital allowances whether they are purchased separately or as part of the purchase of the property. However, it must be remembered that only new, unused assets can qualify for either the super-deduction or the 50% first year allowance.

Where a second-hand property is purchased, the purchaser and seller generally have to agree a value for the qualifying fixtures within the property and make a joint election (known as a 'Section 198 Election'), which the purchaser has to submit to HMRC within two years of the date of purchase in support of their capital allowances claim. The agreed value can be anything between £1 and the original cost to the seller of the qualifying items. Sellers generally prefer a low value as this prevents or minimises balancing charges, but this is a matter for negotiation.

Integral Features

The following items are classed as integral features:

- Electrical lighting and power systems
- Cold water systems
- Space or water heating systems, air conditioning, ventilation and air purification systems and floors or ceilings comprised in such systems
- Lifts, escalators and moving walkways
- External solar shading

For further information regarding capital allowances on property, and assets within property, see the Taxcafe.co.uk guides *'Using a Property Company to Save Tax'* and *'How to Save Property Tax'*.

4.7 THE ANNUAL INVESTMENT ALLOWANCE

The annual investment allowance provides 100% tax relief for qualifying expenditure on plant and machinery up to the specified limit in each accounting period.

Qualifying companies are entitled to an annual investment allowance of up to £1m. This limit was due to fall to just £200,000, but the reduction was postponed twice and then, more recently, it was confirmed the limit would remain at £1m indefinitely.

(The allowance is also available to sole traders and most partnerships. Note, however, that where a company is a member of a partnership, the allowance will not be available to that partnership.)

Until recently, it had been expected that highly restrictive transitional rules would apply where a company's accounting period spans the previously anticipated date of reduction in the specified limit on 1st April 2023. Thankfully, these rules will no longer apply and the £1m maximum limit will now be available to companies with any twelve month accounting period (subject to the restrictions noted below).

Restrictions on the Annual Investment Allowance

The annual investment allowance is not available for:

- Expenditure on cars
- Expenditure incurred in earlier accounting periods where allowances were not previously claimed
- Assets transferred to the company by a connected person (see Appendix C), for example the company owner

The annual investment allowance is restricted where a company has an accounting period of less than twelve months' duration. For example, a company drawing up accounts for the six month period ending 31st December 2022 will be entitled to a maximum annual investment allowance of £504,110 (£1m x 184/365).

The annual investment allowance must be shared between companies that are members of the same group, or which are otherwise closely related to each other. This would include associated companies under the control of the same persons (see

Section 2.5). The allowance can be shared in any proportion the companies agree. Hence, for example, where the same person owns both a trading company and a property investment company, the trading company could claim an annual investment allowance of, say, £900,000 for the year ending 31st December 2022, while the property investment company claims an annual investment allowance of £100,000 for the same period.

However, where a company owner also operates as a sole trader, an individual landlord, or is a member of a partnership, that other business activity attracts its own annual investment allowance and does not need to share the company's annual investment allowance.

Expenditure that Does Not Use Up the Annual Investment Allowance

Expenditure on which either the super-deduction or the 50% first year allowance is claimed, or which qualifies for enhanced capital allowances (see Section 4.9) does not use up any of the company's annual investment allowance for the relevant period.

Interaction with the Super-Deduction

In Sections 4.2 and 4.3, we looked at the overall tax saving produced by expenditure which could either qualify for the super-deduction (if made by 31st March 2023) or would be covered by the annual investment allowance (if made after March 2023).

However, there are some types of expenditure which will qualify for the annual investment allowance, but cannot qualify for the super-deduction. These include:

i) Used and second-hand assets
ii) Assets held for leasing (see Section 4.4)
iii) Assets acquired under contracts entered into before 3rd March 2021
iv) Ships and railway assets
v) Assets (other than cars) falling into the special rate pool (see Section 4.10)

Any expenditure on these assets in excess of the maximum annual investment allowance available for the relevant period will attract:

- The 50% first year allowance for most new assets purchased before 1st April 2023 and falling into the special rate pool (see Sections 4.10 and 4.11 for further details)
- Writing down allowances at just 6% for other assets falling into the special rate pool, including used or second-hand integral features (see Section 4.6)
- Writing down allowances at just 18% in all other cases

In contrast to the immediate 100% relief provided by the annual investment allowance, expenditure attracting writing down allowances at 18% may take twelve years to achieve even 90% relief. For assets falling into the 'special rate pool', it may take almost forty years; although this is reduced to twenty-seven years where the 50% first year allowance is available.

4.8 CALENDAR GIRLS

We've gone through some complex stuff over the last few sections, particularly when it comes to timing expenditure on plant and machinery. So I thought it might be helpful if I used a few examples to further illustrate the position.

We've already looked at the timing of expenditure qualifying for the super-deduction and the effective overall rate of tax saving it generates so, in this section, I will look at expenditure on plant and machinery that qualifies for the annual investment allowance but not for the super-deduction or enhanced capital allowances (Section 4.9). Among other things this includes purchases of used or second hand machinery, equipment, vans, motorcycles, computers, and furniture.

Meet the Calendar Girls

In the examples that follow, each small company owner wants to buy second hand plant and machinery that will qualify for the annual investment allowance. They never spend anywhere near £1m in a year and are currently looking at the timing of their purchases during late 2022 and the 2023 calendar year. All their companies make profits of more than £50,000 each year.

Examples

*April's company has a 30th **April** accounting date. She decides to defer buying assets until at least May 2023, as they will then produce tax relief at either 25% or 26.5% instead of a maximum of just 19.616% for earlier purchases.*

*May's company has a 31st **May** accounting date. She may wish to avoid buying assets before 1st June 2023 as this will only give her tax relief at a maximum effective rate of 20.253%. Deferring the expenditure will provide her company with tax relief at an effective rate of either 25% or 26.5%.*

*June's company has a 30th **June** accounting date. D'you know, I think she might wish to avoid buying assets before her 2023 accounting date as this will only give her tax relief at a maximum effective rate of 20.870%. Maybe she should wait until July to get relief at an effective rate of either 25% or 26.5%.*

*Julie's company has a 31st **July** accounting date. She is duly concerned that assets purchased before her 2023 accounting date will only give her tax relief at a maximum effective rate of 21.507%. Waiting until August will give her company tax relief at an effective rate of either 25% or 26.5%; it could be worth it.*

*Augustine's company has a 31st **August** accounting date. Her august accountant has advised her that asset purchases in her current accounting period ending 31st August 2023 will only give her tax relief at a maximum effective rate of 22.144%. Alternatively, she could wait until September and obtain relief at either 25% or 26.5%. It's worth looking into.*

*Serena's company has a 30th **September** accounting date. She surmises that deferring purchases to October 2023 will give her relief at either 25% or 26.5% instead of a maximum of 22.760% in her current accounting period ending 30th September 2023.*

*Octavia's company has a 31st **October** accounting date. She occasionally considers the fact that buying assets during her accounting period ending 31st October 2023 will only give her tax relief at a maximum effective rate of 23.397% but, on the whole, she doesn't really think it's worth delaying her purchases to November 2023 just to get a small increase in her rate of tax relief to either 25% or 26.5%.*

108

*Nova's company has a 30th **November** accounting date. She knows she will only get tax relief at 19% on expenditure incurred up to 30th November 2022, so she is deferring her purchases until her next accounting period to get relief at up to 24.014%. She also knows there is little point delaying her purchases beyond November 2023 as this would only increase her rate of tax relief slightly more, to either 25% or 26.5%.*

*Desdemona's company has a 31st **December** accounting date. She decides she won't make any further purchases in 2022, as these will only give her tax relief at 19%. However, she is content to make her purchases in 2023 when they will provide tax relief at an effective rate of up to 24.651%, only a little less than the 25% or 26.5% she would get if she delayed her purchases until 2024.*

*Janet's company has a 31st **January** accounting date. She is putting off her expenditure until February 2023 so it will give her tax relief at an effective rate of up to 25.288% instead of the current rate of 19%. She can't see any point in delaying her expenditure beyond January 2024 though, as the additional increase in the rate of tax relief she would get would not be significant.*

*Felicity's company has a 28th **February** accounting date in 2023. She is deferring her expenditure until March 2023 to get tax relief at an effective rate of up to 25.865% instead of the current rate of 19%. She feels fairly relaxed about whether later expenditure is incurred before or after 29th February 2024 as it will make very little difference to the rate of tax relief she gets.*

*Marcia's company has a 31st **March** accounting date. She marvels at the fact she can spend up to £1m in the year ending 31st March 2024 and get tax relief at a rate of either 25% or 26.5%. This is markedly better than her current 19% rate of relief, so she defers as much expenditure as she can until April 2023.*

You may not agree with the calendar girls' opinions on the timing of their investments but, whatever your company's accounting date, if it makes annual profits of more than £50,000, you will face the same situation as one of them.

For small companies with annual profits not exceeding £50,000, the timing of expenditure eligible for the annual investment allowance, but not the super-deduction, will not alter the rate of tax relief they get.

4.9 ENHANCED CAPITAL ALLOWANCES

Enhanced capital allowances of 100% are available for:

- Plant and machinery intended for use in a qualifying activity within a designated Freeport tax site (to 30th September 2026). The allowances are clawed back if the assets are moved out of the tax site within five years.
- Qualifying expenditure in designated Enterprise Zones within assisted areas (this usually applies for a period of eight years after the zone is launched)
- Gas refuelling stations (to 31st March 2025)
- Zero emission goods vehicles (to 31st March 2025)

Further proposals to establish new Investment Zones which would also benefit from enhanced capital allowances are currently under review.

Enhanced capital allowances are available in addition to the annual investment allowance and are not generally subject to any monetary limits. However, they are only available on purchases of new, unused assets.

Most of this expenditure will be eligible for the super-deduction if it is incurred by 31st March 2023. The issues to consider when deciding how to get the best overall tax saving on this expenditure will therefore be the same as we saw in Sections 4.2 and 4.3: except that the points made about 'Big Spenders' with expenditure in excess of the maximum annual investment allowance can be ignored where enhanced capital allowances are available.

Zero emission (all electric) cars are also eligible for a 100% first year allowance, and we will look at this further in Section 4.15.

4.10 WRITING DOWN ALLOWANCES

Qualifying expenditure on plant and machinery that is not eligible for the super-deduction, the 50% first year allowance, or enhanced capital allowances, and which is not covered by the annual investment allowance, is eligible for 'writing down allowances'. The rate of writing down allowances on most plant and machinery is currently 18%, although a reduced rate of 6% applies to expenditure falling into the 'special rate pool' (see further below).

110

Writing down allowances also apply to expenditure on qualifying plant and machinery that is not eligible for the annual investment allowance, including cars and assets purchased from connected persons.

Pooling

Technically, what actually happens is that all of a company's qualifying expenditure on plant and machinery is placed in one of two 'pools', known as the 'main pool' and the 'special rate pool'. There are three exceptions to this:

- Assets qualifying for the super-deduction are not placed in the 'main pool', but are held as separate assets
- Only the unclaimed 50% of assets on which the 50% first year allowance has been claimed goes into the 'special rate pool' (see Section 4.11 for further details)
- Assets subject to a 'short life asset election' are held as separate assets (this facility is not available on cars and is of little use in practice due to the current £1m maximum annual investment allowance and the super-deduction)

The company then deducts its annual investment allowance claim from the amount in the pools. It's worth noting the annual investment allowance may be allocated to expenditure falling into the special rate pool in preference to expenditure falling into the main pool. This is extremely beneficial in most cases and we will take a look at some practical aspects in Sections 4.11 and 4.13.

The company would then also deduct any claim for enhanced capital allowances (Section 4.9) and the lower of disposal proceeds or original cost for any 'pooled' assets sold during the period (Section 4.12).

The remaining balance is treated as follows:

- If it exceeds £1,000, the company may claim writing down allowances at the appropriate rate (18% or 6%) and carry the remainder of the balance forward to the next accounting period
- If it is between £1 and £1,000, the full balance may be claimed immediately
- If it is negative, the company is subject to a 'balancing charge' equal to the negative balance: this is an addition to the company's taxable profits for the period

The Special Rate Pool

The following expenditure must be allocated to the 'special rate pool':

- Cars with CO_2 emissions over a specific level (Section 4.15)
- Integral features (see Section 4.6)
- Expenditure of £100,000 or more on plant and machinery with an anticipated working life of 25 years or more
- Thermal insulation of an existing building (except residential property, but including furnished holiday lets)

Of these, only new integral features and thermal insulation will qualify for the 50% first year allowance which we will look at in the next section.

4.11 THE 50% FIRST YEAR ALLOWANCE

Subject to the exclusions listed in Section 4.4, expenditure on new integral features (see Section 4.6), or thermal insulation of an existing building (as defined in Section 4.10), incurred by companies between 1st April 2021 and 31st March 2023 qualifies for a 50% first year allowance.

The unclaimed 50% of the expenditure is added to the special rate pool (see Section 4.10) and will attract writing down allowances at 6% from the following accounting period onwards. There is no writing down allowance available in the accounting period in which the first year allowance is claimed.

Planning Implications

Although a 50% first year allowance is much better than 6% writing down allowances, it is still not as good as the 100% relief provided by the annual investment allowance. Hence, where the company's total qualifying expenditure does not exceed the maximum annual investment allowance available for the relevant period, it will be far better to claim the annual investment allowance than the 50% first year allowance.

This, in turn, means it will be better for companies making annual profits in excess of £50,000, but spending less than £1m on qualifying plant and machinery, to defer expenditure that would

otherwise qualify for the 50% first year allowance until an accounting period commencing after 31st March 2023.

For companies making annual profits of £50,000 or less, it will not usually make any difference when this type of expenditure is incurred.

Small and Medium-Sized Companies: Summary so Far

The 50% first year allowance is of no benefit to the vast majority of small or medium-sized companies. Ideally, expenditure should be timed so that it is covered by the annual investment allowance and, if the company's annual profits exceed £50,000, deferred until an accounting period commencing after 31st March 2023.

If your company is never likely to spend in excess of the £1m maximum annual investment allowance on qualifying plant and machinery (see Sections 4.5 and 4.6) that's all you need to know and the rest of this section will not affect you.

Choosing What to Claim

An issue some larger companies may face is whether to claim the 50% first year allowance where the company is also incurring expenditure on assets that would fall into the main pool, but which don't qualify for the super-deduction.

This only matters where the total expenditure not qualifying for the super-deduction exceeds the maximum annual investment allowance.

Example
Ullscarf Ltd has a 31st December accounting date. It makes annual profits of around £1.5m. During the period between 1st January and 31st March 2023, it spent £400,000 on new integral features. Later in the year, it spent £750,000 on vans and machinery.

Whatever the company does, it will be able to claim an annual investment allowance of £1m, but which assets should the allowance be allocated to?

Scenario 1: *The company claims the annual investment allowance on the vans and machinery plus £250,000 of the new integral features*
The company can claim the 50% first year allowance on the remaining £150,000 of expenditure on integral features. Ullscarf Ltd's total capital allowances claim is thus:

First year allowance: £150,000 x 50%	*£75,000*
Annual investment allowance:	*£1,000,000*
Total	*£1,075,000*

Scenario 2: *The company claims the annual investment allowance on the integral features plus £600,000 of the vans and machinery*
The company can claim writing down allowances at 18% on the remaining £150,000 of expenditure on vans and machinery. Ullscarf Ltd's total capital allowances claim is thus:

Writing down allowances: £150,000 x 18%	*£27,000*
Annual investment allowance:	*£1,000,000*
Total	*£1,027,000*

The extra tax saving for the year ending 31ˢᵗ December 2023 produced by Scenario 1 is £11,290 (£1.075m – £1.027m = £48,000 x 23.521%: see Appendix A).

Clearly, claiming the annual investment allowance on the assets not qualifying for the 50% first year allowance produces the better result in the first instance. However, the unrelieved expenditure carried forward will attract writing down allowances at different rates in the following year, ending 31ˢᵗ December 2024, as follows:

Scenario 1: £75,000 at 6% =	£4,500
Scenario 2: £123,000 at 18% =	£22,140

The writing down allowances over the next three years under the two scenarios will be:

Year Ending	Scenario 1	Scenario 2
31ˢᵗ December 2025	£4,230	£18,155
31ˢᵗ December 2026	£3,976	£14,887
31ˢᵗ December 2027	£3,738	£12,207

By this point, the benefit produced by Scenario 1 will reverse, as the additional savings in Corporation Tax at 25% produced by Scenario 2 in the subsequent period (2024 to 2027) will total £12,736, putting the company an overall net £1,446 better off than under Scenario 1.

The additional savings produced by Scenario 2 will continue to accumulate thereafter until reaching a total of £18,082 after twelve years, putting the company an overall net £6,792 better off than under Scenario 1.

Things then reverse again with the writing down allowances under Scenario 1 starting to exceed those under Scenario 2. However, the differences by this point are small and the company is still an overall net £5,569 better off under Scenario 2 after twenty years.

In summary, where there is a choice between allocating the annual investment allowance to assets that would otherwise qualify for the 50% first year allowance or to assets falling into the main pool, but not qualifying for the super-deduction:

- Allocating the annual investment allowance to assets falling into the main pool produces greater savings in the first instance, but
- Allocating the annual investment allowance to assets that would otherwise qualify for the 50% first year allowance will produce greater cumulative savings within three or four years, although
- You may decide it is better to take the immediate saving, as the additional long-term savings produced are not great

Note that, in the example, the vans and machinery couldn't qualify for the super-deduction because they were purchased after 31st March 2023. If they were purchased second-hand, the same result would arise whatever part of the year they were purchased in. If they were purchased new, Ullscarf Ltd could have made considerable savings by purchasing at least £150,000 worth of these assets by 31st March 2023 (and further small savings by purchasing the rest of them by that date).

Big Spenders

Where expenditure regularly exceeds the maximum annual investment allowance, it will generally make sense to incur

expenditure on new integral features and thermal insulation by 31st March 2023 in order to benefit from the 50% first year allowance.

Example

Tolmount Ltd has a 31st March accounting date and regularly spends more than £1m on integral features every year. In the period since 1st April 2022 it has already spent more than £1m. In addition to this, the company is also planning to purchase a further new property and will be able to claim capital allowances on the integral features within that property, worth £500,000.

If Tolmount Ltd purchases the new property by 31st March 2023, it will be able to claim a 50% first year allowance on the integral features. This will provide a Corporation Tax saving of £500,000 x 50% x 19% = £47,500.

The unrelieved balance of expenditure carried forward will then provide a further Corporation Tax saving in the following year of £250,000 x 6% x 25% = £3,750, meaning the purchase will have yielded total savings of £51,250 by this point.

If Tolmount Ltd purchases the new property after 31st March 2023, it will only be able to claim writing down allowances at 6%, providing a Corporation Tax saving of just £7,500 (£500,000 x 6% x 25%) by the same point in time.

I have used a marginal Corporation Tax rate of 25% here but, whatever rate we used, we would easily conclude that it is better to ensure the expenditure is incurred by 31st March 2023.

Admittedly, the writing down allowances in future years at 6% will be greater where the first year allowance is not available, but it will take a very long time to recoup the £43,750 difference in the initial saving (at a marginal tax rate of 25% it could take up to twenty-three years).

But what if the annual investment allowance would be available to cover part of the expenditure if it took place in the following year?

To begin with, it is clear that if the annual investment allowance would cover at least 50% of the expenditure then, for companies with annual profits in excess of £50,000, it will generally make sense to defer the expenditure to an accounting period

116

commencing after 31st March 2023 in order to obtain Corporation Tax relief at a higher rate.

But what if the annual investment allowance would cover less than 50% of the expenditure in that later accounting period?

Example Revisited

Let's take the same facts as above, but let us now assume that Tolmount Ltd will only spend £850,000 on other integral features during the year ending 31st March 2024.

As before, purchasing the new property by 31st March 2023 will yield a cumulative tax saving of £51,250 by 31st March 2024.

If the company purchases the new property after 31st March 2023, it will be able to claim the annual investment allowance on £150,000 of the expenditure, but will only be able to claim writing down allowances at 6% on the remaining £350,000. This will give it a total capital allowances claim of £171,000, providing a Corporation Tax saving of £42,750 (£171,000 x 25%).

The company is still better off in the first instance if it purchases the property by 31st March 2023, although it would now only take eight years to recoup the initial difference in tax saved of £8,500 (£51,250 – £42,750) and the cumulative total saving thereafter will be greater if the purchase is deferred until after 31st March 2023.

In terms of the initial tax saving alone, at a marginal Corporation Tax rate of 25%, it is better to defer the purchase until after 31st March 2023 if at least 37.25% of the qualifying expenditure would be covered by the annual investment allowance. Alternatively, where more than 32.6% is covered by the annual investment allowance, it will only take a maximum of five years before the cumulative total tax saving generated by deferring the purchase is greater.

Companies with a future marginal Corporation Tax rate of 26.5% are unlikely to be spending in excess of £1m on integral features, but if this did arise, it would mean greater savings would be available if expenditure were deferred to an accounting period commencing after 31st March 2023 when a significant part of that expenditure would then be covered by the annual investment allowance. In fact, where at least 35% of the future spend would be covered by the annual investment allowance, there would be an

overall initial saving if expenditure is deferred to such an accounting period. Alternatively, where at least 29.5% is covered by the annual investment allowance, it will only take a maximum of five years before the cumulative total tax saving generated by deferring the purchase is greater.

All this assumes the annual investment allowance claim on the additional expenditure does not itself alter the company's marginal Corporation Tax rate (by reducing taxable profits below £50,000) so it's a rather restricted set of circumstances.

In Conclusion

We can summarise the position by saying that it will generally be beneficial for companies with annual profits in excess of £50,000 to defer expenditure that would otherwise qualify for the 50% first year allowance until an accounting period commencing after 31st March 2023 where at least 37.25% of the expenditure would then be covered by the annual investment allowance.

It will also be worth reviewing the position whenever 30% or more of the expenditure would be covered by the annual investment allowance.

All this is assuming the annual investment allowance would not cover the expenditure if it took place by 31st March 2023: that's a different story, which we will look at in Section 4.17.

As always, commercial considerations should usually take precedence, especially where the tax savings involved in altering the timing of a purchase are relatively small.

Periods Straddling 31st March 2023

There are no transitional rules for the 50% first year allowance, it is simply a question of incurring the expenditure by 31st March 2023, regardless of when your company's accounting date is. Hence, when expenditure that will not be covered by the annual investment allowance is to take place during an accounting period that straddles 31st March 2023, it will make sense to ensure the expenditure is incurred by that date.

However, where a significant part of the expenditure (say 30% or more) would be covered by the annual investment allowance if it

118

were deferred to a later accounting period, it will be worth reviewing the position as such a deferral may lead to greater tax savings.

4.12 DISPOSALS

As explained in Section 4.10, the normal rule is that any proceeds received on the disposal of plant and machinery are deducted from the relevant pool, although this is restricted to the asset's original cost where this is lower. This includes disposal proceeds for company cars.

If the deduction creates a negative balance, the company is subject to a balancing charge.

Special rules apply to assets on which either the super-deduction or the 50% first year allowance have been claimed. Disposal proceeds for these assets lead to an immediate balancing charge equal to the proceeds multiplied by:

- 50% for assets on which the 50% first year allowance has been claimed (the other 50% is deducted from the special rate pool)

- For assets on which the super-deduction is claimed and which are disposed of in an accounting period beginning before 1st April 2023, the same percentage as would be available as a super-deduction for a new asset acquired in the same accounting period (e.g. 130% where the asset is disposed of during any accounting period ending before 1st April 2023; or 107.4% where the asset is disposed of during the year ending 31st December 2023). See Section 4.3 for details of the applicable rates for other accounting periods straddling 31st March 2023.

For assets on which the super-deduction was claimed, which are disposed of in an accounting period beginning after 31st March 2023, the balancing charge is simply equal to the disposal proceeds.

The effective cost of proceeds received on the disposal of assets on which the super-deduction was claimed, where the disposal takes place during an accounting period straddling 31st March 2023, is as

per the table in Section 4.3 (the savings shown at the different marginal tax rates become the cost).

Practical Implications

The practical result of these rules is that company owners will need to separately identify, and keep track of, every item on which they have claimed either the super-deduction or the 50% first year allowance in order to deal with any future disposal proceeds correctly.

Disposals and Marginal Rate Planning

As usual, I am only considering the tax implications of the disposals here. Commercial considerations should usually take precedence. In particular, it is unlikely that many companies will want to dispose of assets on which the super-deduction has been claimed (and thus purchased between April 2021 and March 2023) in the near future. However, I am only looking at the tax cost of those disposals here.

For small companies with annual profits not exceeding £50,000, disposals of assets on which the super-deduction has been claimed should generally be deferred until an accounting period beginning after 31st March 2023. The timing of other disposals giving rise to a balancing charge will not alter the Corporation Tax cost arising.

For medium-sized companies with annual profits between £50,000 and £250,000, any disposals giving rise to a balancing charge should ideally take place in an accounting period ending before 1st April 2023. In most cases, this will make a difference of up to 7.5% in the Corporation Tax cost arising, although, in the case of assets on which the super-deduction has been claimed, it will never make a difference of more than 1.8%.

For large companies with annual profits over £250,000, the timing of the disposal of assets on which the super-deduction has been claimed will make very little difference to the Corporation Tax cost arising (which ranges from 24.7% to 25.3%). Other disposals giving rise to a balancing charge should ideally take place in an accounting period ending before 1st April 2023, as this will make a difference of up to 6% in the Corporation Tax cost arising.

4.13 PUTTING IT ALL TOGETHER

Let's look at an example to see how capital allowances on plant and machinery might work in practice.

Example V

Venchen Ltd began trading on 1st January 2023. During the year ending 31st December 2023, the company spends £1.65m on qualifying plant and machinery, made up of:

- *£250,000 spent on new commercial vehicles and machinery between January and March 2023*
- *£400,000 spent on new commercial vehicles and machinery between April and December 2023*
- *£500,000 spent on various second-hand commercial vehicles and machinery throughout the year*
- *£350,000 on integral features within new business premises purchased directly from a developer in January 2023*
- *£150,000 on other fixtures qualifying as plant and machinery for capital allowances purposes within the same business premises (see Section 4.6)*

Both the new commercial vehicles and machinery purchased between January and March, and the fixtures within the new business premises (excluding integral features) purchased in January (a total of £400,000) will be eligible for the super-deduction. However, the super-deduction will be subject to the transitional rules as the company's accounting period straddles 31st March 2023 (see Section 4.3). The company therefore gets a super-deduction of £400,000 x 107.4% = £429,600.

As we saw in Section 4.7, the company can only claim a maximum of £1m annual investment allowance for the year. Believing that a bird in the hand is worth two in the bush, the company's accountant decides to allocate its annual investment allowance to the plant and machinery falling into the main pool first, in priority to the integral features purchased in January 2023 (in order to maximise the immediate tax relief in the first year: see Section 4.11).

The company's capital allowances computation therefore looks like this:

Venchen Ltd: Capital Allowances Computation for Year Ending 31st December 2023

	Main Pool	Special Rate Pool
Additions	£900,000*	£350,000
Annual investment allowance	(£900,000)	(£100,000)
	-	£250,000
First year allowance @ 50%	-	(£125,000)
	-	£125,000
Writing down allowance @ 6%	-	(£7,500)
Unrelieved balance carried forward	-	£117,500

* Total spend on second-hand commercial vehicles and machinery for the whole year plus spend on new commercial vehicles and machinery after 31st March 2023 (£500,000 + £400,000)

To summarise, the company has obtained relief as follows:

Super-deduction	£429,600
Annual investment allowance	£1,000,000
First year allowance	£125,000
Writing down allowance	£7,500
Total	£1,562,100

The company has obtained a total of £1,562,100 in relief for its £1.65m of qualifying expenditure and has £117,500 of unrelieved expenditure carried forward.

In the following year, the company will be eligible for writing down allowances on the unrelieved balance in its special rate pool, as well as any further expenditure not covered by the annual investment allowance.

Let's say that, during the year ending 31st December 2024, the company spends a further £150,000 on integral features and £975,000 on commercial vehicles and machinery. Its capital allowances computation therefore looks like this:

Venchen Ltd: Capital Allowances Computation for Year Ending 31st December 2024

	Main Pool	Special Rate Pool
Unrelieved balance brought forward	-	£117,500
Additions	£975,000	£150,000
Annual investment allowance	(£850,000)	(£150,000)
	---------------	-------------
	£125,000	£117,500
Writing down allowance @ 18%/6%	(£22,500)	(£7,050)
	---------------	-------------
Unrelieved balance carried forward	£102,500	£110,450

This time the company's capital allowances claim totals £1,029,550, made up of the maximum annual investment allowance of £1m plus writing down allowances of £29,550 (£22,500 + £7,050).

During the year ending 31st December 2025, the company spends a total of £1.2m on new commercial vehicles and machinery.

It sells some of the second-hand machinery it purchased in 2023 for a total of £130,000 (all the machinery is sold for less than the company's original purchase price). It also sells a commercial vehicle it bought new in January 2023, and claimed the super-deduction on. The sale proceeds for the vehicle are £60,000.

The company decides to strip out the heating system in the property it purchased in January 2023 and replace it with something more energy-efficient. It receives £10,000 for scrapping the old heating system and spends £160,000 on the new system. Both are classed as integral features (see Section 4.6).

The £10,000 proceeds for the old heating system needs to be split between the element covered by the 50% first year allowance and the remainder.

In this case, deriving the element covered by the 50% first year allowance is a little more complex, as part of the cost was covered by the annual investment allowance. In most cases, this element will simply be 50%. However, this time it is £10,000 x £125,000/£350,000 = £3,571. The company thus has a balancing charge of £3,571 on the disposal of the old heating system, leaving £6,429 to be deducted from the special rate pool.

Venchen Ltd also has a balancing charge of £60,000 on the sale of the commercial vehicle it had claimed the super-deduction on, giving it total balancing charges of £63,571.

The rest of its capital allowances computation looks like this:

Venchen Ltd: Capital Allowances Computation for Year Ending 31st December 2025

	Main Pool	Special Rate Pool
Unrelieved balance brought forward	£102,500	£110,450
Additions	£1,200,000	£160,000
Annual investment allowance	(£840,000)	(£160,000)
Disposals	(£130,000)	(£6,429)
	---------------	---------------
	£332,500	£104,021
Writing down allowance @ 18%/6%	(£59,850)	(£6,241)
	---------------	-------------
Unrelieved balance carried forward	£272,650	£97,780

The company's capital allowances claim totals £1,066,091, made up of the maximum annual investment allowance of £1m plus writing down allowances of £66,091 (£59,850 + £6,241). If we deduct the balancing charges of £63,571, the overall net claim amounts to £1,002,520.

4.14 CAPITAL ALLOWANCES FOR SMALL COMPANIES IN PRACTICE

The level of complexity we saw in Example V in Section 4.13 arose because the company spent more on qualifying plant and machinery not eligible for the super-deduction than its available annual investment allowance. Many small companies are unlikely to ever spend more than the maximum annual investment allowance and hence will probably never need to be concerned with writing down allowances and complex calculations like those set out in Section 4.13. However, there are a couple of issues I would like to point out.

Cars are not eligible for either the super-deduction or the annual investment allowance. Hence, purchases of company cars result in more complex capital allowances calculations (see Section 4.15).

Where all of a company's plant and machinery purchases have been covered by either the super-deduction or the annual investment allowance, the balance of unrelieved expenditure on its capital allowances pools will be nil. This means any sale proceeds received for the disposal of plant and machinery will effectively be immediately taxable in full (see Section 4.10).

4.15 COMPANY CARS

The capital allowances regime for cars purchased by companies can briefly be summarised as follows:

- Cars are not eligible for the annual investment allowance, the super-deduction, or the 50% first year allowance
- Cars with CO_2 emissions over the 'higher threshold' fall into the special rate pool and attract writing down allowances at just 6%
- Cars with CO_2 emissions that are not over the 'higher threshold', fall into the main pool and attract writing down allowances at 18%, except that
- New cars with CO_2 emissions of no more than the 'lower threshold' attract enhanced capital allowances at 100%

The 'higher threshold' for cars purchased after 31st March 2021 is just 50g/km.

The 'lower threshold' for cars purchased after 31st March 2021 is zero, meaning only fully electric cars can now qualify for the 100% first year allowance. As with other enhanced capital allowances (see Section 4.9), the car must be purchased new.

Company Cars and Marginal Rate Planning

For companies with annual profits over £50,000, delaying the purchase of a new electric car until the beginning of the first accounting period commencing after 31st March 2023 will yield additional savings. The timing of other company car purchases will make very little difference to the overall tax savings achieved.

For companies with annual profits of £50,000 or less, the timing of car purchases makes no difference to the overall tax savings achieved.

Finally, all company owners intending to purchase new electric cars through their company should be aware that the 100% enhanced capital allowances will be reviewed some time in the next few years and may be withdrawn at some future date. This would obviously make it disadvantageous to delay the purchase beyond the date of withdrawal.

4.16 MARGINAL RATE PLANNING FOR PLANT AND MACHINERY

Throughout this chapter we have looked at how the complex nuances of the capital allowances regime for plant and machinery interact with the Corporation Tax changes we looked at in Chapter 2.

In this section, I thought it might just be useful if I summarise our conclusions regarding marginal rate planning on plant and machinery purchases. The position for disposals was summarised in Section 4.12.

Here I am only considering Corporation Tax. In practice, commercial considerations, cashflow, and other tax issues (such as VAT recovery, or benefit in kind charges on company cars) should be taken into account and may need to take precedence.

I will divide this into four categories of company, based on annual profits and expenditure on plant and machinery. For the first three categories, I am going to assume the company will never spend in excess of the maximum available annual investment allowance; however the points made in previous sections should be borne in mind.

Remember also that the annual profit limits of £50,000 and £250,000 must be reduced when the company has any associated companies (Section 2.4) or draws up accounts for a period of less than twelve months. The maximum annual investment allowance is also reduced for accounting periods of less than twelve months and must be shared with associated companies (see Section 4.7).

Small Companies (Annual Profits of £50,000 or less)

Assets qualifying for the super-deduction should be purchased in an accounting period ending before 1st April 2023. The timing of other plant and machinery purchases makes no difference to the company's overall Corporation Tax saving.

Medium-Sized Companies (Annual Profits between £50,000 and £250,000)

All plant and machinery purchases should be delayed until an accounting period beginning after 31st March 2023 wherever possible, with the exception of company cars other than new electric cars.

Savings of up to 7.5% are available on purchases covered by the annual investment allowance (but not qualifying for the super-deduction), and new electric cars. This also includes other assets qualifying for enhanced capital allowances but not qualifying for the super-deduction.

The maximum saving on assets that would qualify for the super-deduction is generally only 1.8%. However, companies with accounting dates between April and November should generally avoid purchasing assets that would otherwise qualify for the super-deduction between 1st April 2023 and the end of the accounting period straddling that date.

Larger Companies (Annual Profits over £250,000; but Annual Spend on Plant and Machinery not exceeding the Annual Investment Allowance)

Purchases of assets covered by the annual investment allowance, but not qualifying for the super-deduction; new electric cars; and other assets qualifying for enhanced capital allowances, but not the super-deduction; should be delayed until an accounting period beginning after 31st March 2023 wherever possible, to yield savings of up to 6%.

The timing of other plant and machinery purchases will generally make little or no difference to the tax savings arising. However, companies with accounting dates between April and November should generally avoid purchasing assets that would otherwise

qualify for the super-deduction between 1st April 2023 and the end of the accounting period straddling that date.

Large Companies (Annual Profits over £250,000 and Annual Spend on Plant and Machinery exceeding the Annual Investment Allowance)

Assets qualifying for the super-deduction, but not for enhanced capital allowances, should be purchased by 31st March 2023.

Assets qualifying for the 50% first year allowance should also generally be purchased by 31st March 2023. For companies that do not have a 31st March accounting date, the best time to purchase assets qualifying for the 50% first year allowance is during an accounting period that straddles 31st March 2023, but before that date.

Purchases of new electric cars; and other assets qualifying for enhanced capital allowances, but not the super-deduction; should be delayed until an accounting period beginning after 31st March 2023 wherever possible, to yield savings of up to 6%.

Where the company is purchasing assets that qualify for the annual investment allowance, but not the super-deduction, it should try to time these purchases so that the annual investment allowance is fully utilised in each accounting period, or at least as much as possible. (It is possible that, once assets qualifying for the super-deduction are excluded, the company may not fully utilise its annual investment allowance in accounting periods falling into the period 1st April 2021 to 31st March 2023.)

The timing of the purchase of assets that qualify for both the super-deduction and enhanced capital allowances, and company cars other than new electric cars, will make little or no difference to the company's Corporation Tax saving.

I think that covers almost everything, except for one last question that we will look at in the next section.

4.17 OCCASIONAL BIG SPENDERS

Throughout most of the previous sections, I have generally assumed companies either never spend more than their maximum available annual investment allowance, or always do.

However, there are obviously some companies that sometimes spend more than the maximum available annual investment allowance and sometimes do not.

For such occasional big spenders, it generally makes sense to bring forward any expenditure qualifying for either the super-deduction or the 50% first year allowance so that it is incurred by 31st March 2023 whenever there is any risk that the expenditure might not be covered by the annual investment allowance if it were incurred at a later date. (See Section 4.11 for a more detailed examination of the position regarding expenditure qualifying for the 50% first year allowance.)

It also usually makes sense for occasional big spenders to try to time their spending to make the most of the available annual investment allowance in each accounting period.

However, where expenditure does not qualify for the super-deduction, is it better to incur the expenditure in an accounting period where it is covered by the annual investment allowance, but only provides tax relief at 19%, or to delay it to a later accounting period where it will only attract writing down allowances but these will provide tax relief at 25% or 26.5%?

Example
Windlestraw Ltd makes annual profits of over £1.5m and has a 31st March accounting date. In the period since 1st April 2022, it has already spent £400,000 on second-hand plant and machinery. It is now contemplating spending a further £300,000 on second-hand commercial vehicles; £200,000 on new integral features; and £100,000 on integral features within a second-hand commercial property.

If the company makes its purchases by 31st March 2023, they will all be covered by the annual investment allowance, thus providing immediate tax savings, but only at 19%.

Alternatively, the company could delay the expenditure until its next accounting period to get Corporation Tax relief at 25%. Unfortunately,

however, it is already committed to other expenditure on plant and machinery of more than £1m in the year ending 31ˢᵗ March 2024. Hence, delaying the expenditure will mean it only attracts writing down allowances.

For the commercial vehicles, the rate of writing down allowances will be 18%. It will take eight years for the Corporation Tax saved at 25% to exceed the amount that could have been saved if the expenditure has been incurred in the year ending 31ˢᵗ March 2023.

For the integral features (both new and second-hand), the rate of writing down allowances will be 6%. It will take twenty-four years for the Corporation Tax saved at 25% to exceed the amount that could have been saved if the expenditure has been incurred in the year ending 31ˢᵗ March 2023.

Even if the company's future marginal Corporation Tax rate were 26.5% instead of 25%, it would still take seven years for the writing down allowances on assets falling into the main pool to produce greater savings than the company would have obtained if it had incurred the expenditure by 31ˢᵗ March 2023. For the integral features, it would take twenty-one years.

In summary, it does not seem worthwhile delaying expenditure that could otherwise be covered by the annual investment allowance if it will only attract writing down allowances in the future. In my view, the time it takes to produce a better overall tax saving is too long.

4.18 CAPITAL ALLOWANCE DISCLAIMERS

With the exception of balancing allowances, capital allowances are not compulsory. A company can choose not to claim some or all of the allowances available to it. For ease of reference, I will call this a disclaimer, although that is no longer the official term and all the company has to do is simply not claim the full allowances it is entitled to.

Any proportion of the available allowances may be disclaimed. Disclaiming allowances in one period means there will be a greater balance of unrelieved expenditure carried forward for relief in the next period.

So, it's tempting to think that disclaiming capital allowances when the company's Corporation Tax rate is only 19% might lead to greater savings in the long run if the company's marginal Corporation Tax rate increases to 25% or 26.5%.

However, by disclaiming the super-deduction, the annual investment allowance, enhanced capital allowances, or the 50% first year allowance, the balance carried forward will then only attract writing down allowances in the future.

Disclaiming the super-deduction in an accounting period ending before 1st April 2023 will almost never be a good idea: it would take at least fourteen years to obtain the same overall tax saving, even when the company's marginal Corporation Tax rate increases to 26.5%.

Disclaiming the super-deduction in an accounting period straddling 1st April 2023 could be even worse. Where the company has profits for that period in excess of £50,000, it will take at least fifteen years to obtain the same overall tax saving and, in some cases, that point can never be reached.

Where the company has profits of £50,000 or less in an accounting period straddling 1st April 2023, but has profits above that level in future years, the period required to obtain the same overall tax saving if the super-deduction is disclaimed will be shorter, but will still be at least seven years.

Disclaiming the annual investment allowance or enhanced capital allowances on plant and machinery falling into the main pool in an accounting period where the company is paying Corporation Tax at 19% will mean waiting at least seven years to obtain the same overall tax saving.

Disclaiming the annual investment allowance or the 50% first year allowance on integral features or other assets falling into the special rate pool will mean waiting at least twenty-one years to obtain the same overall tax saving.

What about Disclaiming Writing Down Allowances?

Disclaiming writing down allowances has less of an impact, as the same allowances are then available next year. At first sight, this might appear to suggest it could be worth disclaiming writing

down allowances when the company's current marginal Corporation Tax rate is 19% but will increase to 25% or 26.5% next year. This could happen for one of two reasons:

- Company's profits are greater than £50,000 per year and the current accounting period ends before 1st April 2023
- If the company claimed all its capital allowances in full this year, its taxable profit would be reduced below £50,000, but its taxable profit will be more than £50,000 next year

Under both scenarios, disclaiming some of the company's writing down allowances will enable it to claim greater allowances next year when they will provide a higher rate of Corporation Tax relief. With a potential difference in the company's Corporation Tax rate of up to 7.5%, it sounds like a good idea, but it's not that simple.

Example
Dollywaggon Ltd has a 31st March accounting date and makes annual profits of around £200,000. At 1st April 2022, the balance brought forward on its main pool is £100,000. Hence in the year ending 31st March 2023, the company is entitled to claim writing down allowances, at 18%, of £18,000. This claim will save the company £3,420 in Corporation Tax (£18,000 x 19%).

Dolly, the company's owner, wonders if it would be a good idea to disclaim the writing down allowances so that they will provide Corporation Tax relief at 26.5% next year, saving the company £4,770 instead (£18,000 x 26.5%).

Kenny, the company's accountant, points out that, even if the company claims the writing down allowances in the year ending 31st March 2023, it will still have a balance of unrelieved expenditure of £82,000 on 1st April 2023. This will enable it to claim writing down allowances of £14,760 next year, producing a saving of £3,911 (at 26.5%).

"That's a total saving of £7,331 over the two years," says Kenny, "which is much better than you'd get by making the disclaimer."

"Yes," replies Dolly, "but won't we make more savings in later years as well if we make the disclaimer?"

"Sure," says Kenny, "but it's gonna take at least seven years to get back the extra tax we'd be paying this year."

132

Once again, we can see that capital allowance disclaimers will take too long to produce any overall benefit to be worthwhile.

But there is one situation where disclaimers could be worthwhile: where a balancing charge (see Section 4.10) is anticipated in the near future.

Future Disposals

So far we have seen that any capital allowance disclaimer will generally take at least seven years to produce an overall tax saving, considerably longer in some cases. However, that timescale could be shortened where asset disposals are planned in the near future.

Example Revisited
After her conversation with Kenny, Dolly remembers she is planning to sell off some of the company's older trucks next year and expects to receive disposal proceeds of £125,000, thus leading to a balancing charge. She asks Kenny if this makes any difference.

"Oh, yeah, big difference," Kenny nods; "if you don't do the disclaimer, you'll get that saving of £3,420 this year, but you'll have a balancing charge of £43,000 next year, which, at 26.5%, will cost you £11,395. That's a net cost of £7,975 over the two years.

"On the other hand, if you disclaim this year's allowances, the balancing charge will only be £25,000, which, at 26.5%, will cost the company £6,625. So, you'll be £1,350 better off."

"I was right all along then," smiles Dolly.

"Well, only 'cause you're selling the trucks," says Kenny.

Disclaiming most types of capital allowances on plant and machinery will be beneficial under these circumstances, including the annual investment allowance, enhanced capital allowances, and the 50% first year allowance; as well as writing down allowances. However, this is subject to a few words of warning:

- It is not worth disclaiming more than is necessary to eliminate the balancing charge. Any excess disclaimer will take the same timescales as we saw above (at least seven years, possibly more) to yield any saving

- The last thing you would want to disclaim would be the super-deduction, as the savings involved would certainly be smaller, and there may even sometimes be an overall cost. Furthermore, a partial disclaimer of the super-deduction on any individual asset would have no effect on balancing charges arising on the disposal of any other asset

- The main pool and the special rate pool operate independently. A disclaimer of capital allowances on assets falling into one pool will not affect a balancing charge on the other pool

Summary and Further Points

Capital allowance disclaimers are not generally worthwhile as a means to yield future Corporation Tax savings, as the time taken to achieve an overall saving is usually too long.

There is a major exception, however, where a disclaimer of allowances yielding Corporation Tax relief at just 19% now can help to reduce or eliminate a balancing charge taxed at 25% or 26.5% in the near future.

Another potential exception arises in the case of 'short-life' assets, which we will examine in the next section.

Finally, it is worth pointing out that disclaimers might also prove beneficial if the company ceases business in the near future, and has a marginal Corporation Tax rate of 25% or 26.5% at that time.

4.19 SHORT-LIFE ASSETS

Short-life asset elections are a useful tax planning tool for companies spending in excess of the maximum available annual investment allowance. This much is true at any time but short-life asset elections may provide even greater benefits for companies that are also facing an increase in their marginal Corporation Tax rate.

A short-life asset election enables a company to obtain full relief for the economic cost of an asset over its working life rather than wait many years to obtain it through writing down allowances alone.

Making the election means that an asset is effectively 'depooled' and kept in its own separate pool for capital allowances purposes until the expiry of a statutory 'cut-off period'. If the asset is sold or scrapped during this period, a balancing allowance or charge arises; if not, the remaining balance is transferred to the main pool.

The 'cut-off period' is eight years from the end of the accounting period in which the asset was purchased. Cars, integral features, and other assets falling into the special rate pool are ineligible for a short-life asset election.

The time limit for making a short life asset election is two years from the end of the accounting period. This enables companies to benefit from a fair amount of hindsight. For example, a company with a 31st December accounting date would have until 31st December 2023 to decide whether to make a short-life asset election in respect of an asset purchased in January 2021.

Naturally, there is no point making short-life asset elections in respect of assets purchased between April 2021 and March 2023 which are eligible for the super-deduction. But there may still be opportunities to undertake some planning in respect of earlier purchases, as well as assets that are not eligible for the super-deduction, such as second-hand commercial vehicles or machinery.

Example
During the year ended 31st March 2021, Grasmoor Ltd spent over £1.1m on new machinery, fixtures and fittings, and integral features. This included £100,000 spent on computer equipment.

By early 2023, it is clear the computer equipment is rapidly becoming obsolete and is likely to need replacing during the year ending 31st March 2024. The estimated sale proceeds for the old equipment are £10,000.

Without a short-life asset election, the old equipment will only attract writing down allowances at 18% and the sale proceeds will simply be deducted from the main pool.

If the company does make an election, however, it will benefit from a balancing allowance in the year ending 31st March 2024. The allowances arising under the two scenarios can be compared as follows:

Year Ending	Allowances	
	Without Election	With Election
31-Mar-2021	£18,000	£18,000
31-Mar-2022	£14,760	£14,760
31-Mar-2023	£12,103	£12,103
31-Mar-2024	£8,125	£45,137
31-Mar-2025	£6,662	
31-Mar-2026	£5,463	
31-Mar-2027	£4,480	
31-Mar-2028	£3,673	
31-Mar-2029	£3,012	
31-Mar-2030	£2,470	
10 Year Total	£78,748	£90,000

As we can see, with the short-life asset election, the total economic cost of the equipment (purchase cost of £100,000 less sale proceeds of £10,000) has been relieved within four years whereas, without the election, only 87% of that cost has been relieved even after ten years.

Already we can see the value of the election, but what if we also factor in the increase in the company's Corporation Tax rate **and** assume that the company disclaims the writing down allowances on the equipment in the first three years. We already know such a disclaimer is not worthwhile without the election (see Section 4.18), but where there is a short-life asset election this approach could yield significant savings.

Assuming (as seems likely) that Grasmoor Ltd has annual profits in excess of £250,000, the total tax saved in our example, with a short-life asset election, but without a disclaimer is:

Writing down allowances 2021 to 2023
£18,000 + £14,760 + £12,103 = £44,863 x 19% = £8,524
Balancing allowance 2024
£45,137 x 25% = £11,284
Total £19,808

With both an election and a disclaimer, the tax saving is:

Balancing allowance 2024
£90,000 x 25% = £22,500

That's an extra saving of £2,692 or, perhaps more importantly, a 13.6% increase in the amount saved. That could be worth waiting for.

Alternatively, the company could claim the writing down allowances in the first year, disclaim them in years two and three, and still get a saving of £1,612 with only a two year wait to reap the benefit; or claim the writing down allowances the first two years and only disclaim them in the third year for a saving of £726 with only a one year wait.

But, whatever you think about the merits of the extra tax savings produced by the disclaimers, the short-life asset election is definitely worthwhile.

Delaying Short-Life Disposals

Where there is a short-life asset election in place and the relevant asset is likely to yield a balancing allowance on disposal, it could be worth waiting until an accounting period commencing after 31st March 2023 to make the disposal in order to obtain Corporation Tax relief at a higher rate. This is provided the delay does not go beyond the expiry of the relevant eight year cut-off period (see above).

Conversely, where a balancing charge is likely to arise, it will be better to either dispose of the asset in an earlier accounting period when the company is still paying Corporation Tax at 19%, or retain the asset until after the expiry of the relevant cut-off period.

4.20 OLD OR NEW?

A couple of years ago, I needed a new laptop. A friend persuaded me there were many good quality reconditioned laptops available at a much lower price than new ones. So I bought a reconditioned laptop for £388 instead of spending around £1,200 on a new one of a similar standard. And my friend was right; the laptop is perfect for my needs and works just fine: I'm using it now.

Imagine I had been buying the laptop now, through a company. To get the super-deduction, I would need to spend £1,200 on a

new laptop. That would give me a Corporation Tax saving of £296 (£1,200 x 130% x 19%).

My reconditioned laptop would only give me a saving of £74 (£388 x 19%); or, if I had a large company spending in excess of the maximum available annual investment allowance, my saving this year would be just £13 (£388 x 18% x 19%).

But, here's the point, the net, after tax cost of a new laptop would still be £904, whereas the after tax cost of my reconditioned laptop would be either £312 or £375: in either case, it's considerably less.

And this illustrates the fact that buying new (i.e. spending more) just to get the super-deduction will often be unwise. Here's another example.

Example
Jane is a heating engineer, running her business through her company, Yoke Ltd. She needs to buy a new van. She can buy a new one for £30,000, or a second-hand one for £15,000.

The new van will provide a Corporation Tax saving of £7,410 (£30,000 x 130% x 19%), giving Jane a net, after tax cost, of £22,590.

The second-hand van will provide a Corporation Tax saving of £2,850 (£15,000 x 19%), giving Jane a net, after tax cost, of £12,150.

As far as the purchase itself is concerned, Jane will be £10,440 better off if she buys the second-hand van. However, she will want to factor in other issues, such as running costs, reliability, and how long the second-hand van's useful working life is likely to be. Nonetheless, in many cases, the second-hand van will remain the better choice, regardless of the fact it does not qualify for the super-deduction.

It reminds me of something I was taught early in my career and which has stood me in good stead ever since:

'Never Let the Tax Tail Wag the Commercial Dog!'

Furthermore, if Yoke Ltd is making annual profits over £50,000, Jane might get the best of both worlds by delaying her purchase of the second-hand van until after 31st March 2023, giving her a Corporation Tax saving of up to £3,975 (£15,000 x 26.5%), and a

net, after tax cost perhaps as low as £11,025: but only if the commercial dog is happy with the delay!

4.21 SWEAT THE SMALL STUFF

One of the important practical benefits of the annual investment allowance is that for the vast majority of companies, it generally makes little difference to their tax position whether small items of equipment, small tools, and other low cost assets are treated as capital expenditure, or written off as replacements, office stationery, or another suitable expense heading.

But, for purchases of new items between April 2021 and March 2023, *it does matter!*

That, of course, is because of the super-deduction. Expenditure on new, unused items of equipment during this period will provide relief on up to 130% of the cost if they are treated as capital expenditure.

Imagine a company with 100 employees provides each of them with a new stapler during the year ending 31st March 2023. The total cost is £400 (they're good staplers). If this is treated as capital expenditure, the company will get Corporation Tax relief on £520 (£400 x 130%), if it is simply treated as office stationery, the relief will be on just £400.

Not everything can be treated as capital expenditure though. This treatment cannot apply to:

- Trading stock (goods purchased for resale)
- Consumable items (e.g. printer ink, staples, paper)
- Repairs expenditure

The general rule is an asset must provide an enduring benefit lasting at least two years before it can be treated as capital expenditure. But there is no rule to say how much it has to cost. Hence, small items that it could be worth treating as capital expenditure eligible for the super-deduction include:

- Staplers, hole punches, rulers, calculators, shredders, and other small items of office equipment
- Cutlery, crockery, kettles, microwave ovens, toasters, and kitchen utensils
- Clocks
- Portable hard drives and memory sticks
- Desk lamps, fans, heaters, waste paper bins
- Furniture (usually treated as capital expenditure but smaller items sometimes aren't)
- Small tools (e.g. hammers, saws, screwdrivers, and gardening equipment)
- Vaccum cleaners, mops, brushes, and other cleaning equipment

Many larger companies have their own threshold which they apply to determine whether any expense should be treated as capital expenditure in their accounts. This is generally accepted by HMRC provided the threshold used is reasonable by comparison with the size of the company (I doubt that BT treat their staplers as capital expenditure). While the super-deduction is available, however, it may make sense to reduce the threshold the company applies: although this does carry the risk HMRC might expect the company to continue applying the reduced threshold in future.

Treating as much as you can of the cost of new equipment, tools, and other small items bought between April 2021 and March 2023 as capital expenditure could save your company a lot of Corporation Tax. However, do bear in mind some of the practical issues arising, as you will need to keep track of every asset on which you claim the super-deduction until you dispose of it (see Section 4.12).

4.22 SOME FINAL POINTS ON TIMING

Assets bought on hire purchase are treated as if they were purchased on the date they are first brought into use in the business.

Subject to this, assets bought on extended credit terms of more than four months are treated as if they were purchased on the date payment is due.

Assets purchased before a qualifying activity commences (e.g. a trade or property letting business) are generally treated for capital allowances purposes as if they were purchased on the date the activity commences. However, this does not alter the timing of the purchase for the purposes of determining eligibility for the super-deduction or the 50% first year allowance.

For example, if a company purchased some new machinery in February 2021 prior to commencing a trade on 1st May 2021, it would not be eligible for the super-deduction on that expenditure even though, otherwise, the expenditure is treated as if it were incurred on 1st May 2021.

Chapter 5

The Trading Loss Carry Back Extension

5.1 INTRODUCTION

In the March 2021 Budget, the former Chancellor announced a temporary extension to the facility for companies to carry back trading losses arising during accounting periods ending between 1st April 2020 and 31st March 2022. As companies have until two years after the end of the loss-making accounting period to claim this relief, it is still worth us including it in this guide.

The temporary facility applies only to trading losses, not to rental losses (not even on furnished holiday lets), surplus non-trading interest costs, capital losses, or any other form of loss.

The new relief operates in addition to existing loss relief rules, which remain unchanged, so it is worth us taking a brief look at those first.

5.2 EXISTING RELIEF BEFORE EXTENSION

The existing loss relief available to companies incurring trading losses remains unchanged and can be summarised as follows.

Current Year Set-Off

Trading losses may be set off against the company's other income *and capital gains* of the same accounting period.

Loss Carry Back

If the claim for set-off of trading losses within the same accounting period has been made, the company may additionally claim to carry back any surplus loss against its total profits and capital gains

in the twelve months preceding the accounting period that gave rise to the loss.

If, however, the loss-making trade was not being carried on by the company throughout the previous twelve months, the relevant period for loss set-off is the period beginning with the commencement of that trade.

Loss Carry Forward

Any further trading losses still remaining unrelieved after any claim for set-off in the current year or carry back to previous years, will be carried forward for set-off in future periods as follows:

- Losses arising after March 2017 may be set off against the company's total income and capital gains, provided the trade that gave rise to the loss has not ceased or become 'small'. Where the trade has become 'small', the carried forward losses may only be set off against future profits from that trade. There is no definition of what 'small' means, although it seems safe to assume it means the trade has become far smaller than it was when it gave rise to the losses.
- Losses arising before April 2017 may only be set off against future profits from the same trade.

Before 2017, losses carried forward were automatically set against future profits from the same trade but companies must now claim this relief.

The total amount of relief a company, or group of companies, may claim for brought forward losses of all types, is restricted to a maximum of £5m plus 50% of any profits in excess of that amount. The £5m limit applies on an annual basis (e.g. the limit would be £2.5m for a six month period).

Companies that are members of a group may also surrender some or all of their trading losses as group relief (see Section 2.9).

Loss relief claims must be made within two years of the end of the loss-making accounting period in the case of losses set off against profits and capital gains within the same period or the previous twelve months; or within two years of the end of the period for which relief is claimed in the case of losses carried forward.

5.3 EXTENDED CARRY BACKS

Up to £2m of trading losses arising during company accounting periods ending in each of the 2020 and 2021 Financial Years (see Section 1.2) may be carried back for set off in the three previous years. The relief operates in addition to existing loss relief rules (Section 5.2).

The £2m limit does not apply to the existing ability to carry losses back one year (Section 5.2), only to any excess carried back to the two years prior to that. The limit applies separately to losses arising in accounting periods ending during the 2020 Financial Year, and during the 2021 Financial Year.

Groups (see Section 2.9) in which any company is eligible to carry back a loss of more than £200,000 must allocate the £2m maximum between the companies in the group. Group companies are, of course, also able to surrender losses as group relief. However, for the remainder of this section, I will assume this option is not available.

Losses carried back may be relieved against the company's total profits (from all sources), including capital gains, in the previous three years. The losses carried back are relieved in later periods in priority to earlier ones.

As with the existing loss relief rules (Section 5.2), where the company has commenced trading within the previous three years, the loss may only be carried back as far as the date on which the company commenced trading.

Small Companies

The £2m limit will not concern most companies, so let's start with an example where it does not apply.

Example
Blaven Ltd has made the following total profits and losses for the years ending 31st December. The losses represent surplus trading losses remaining after set off against any other income or capital gains arising in the same period.

2017: Profit £20,000
2018: Profit £60,000

2019: Profit £30,000
2020: Loss £73,000
2021: Loss £25,000

The loss arising in 2020 needs to be carried back to 2019 first and reduces the profits chargeable to Corporation Tax for that year to nil. The remaining £43,000 can be set off against the 2018 profits.

The loss arising in 2021 needs to be carried back to 2020 first, but there are no profits available. It is then carried back to 2019. However, the company's profits for 2019 have been reduced to nil due to the carry back of losses from 2020, so the 2021 loss is carried back to 2018.

The company's profits for 2018 have been reduced to £17,000 by the carry back of losses from 2020. Hence, £17,000 of the 2021 losses are carried back to 2018 and reduce the taxable profits for that year to nil.

The remaining £8,000 of the 2021 losses can only be carried forward. They cannot go back four years to 2017 and nor was the company able to carry any of its 2020 losses back to 2017, as it was required to set its losses against later years first.

As we can see, the 'later periods' first rule can lead to an effective loss of relief in some cases.

The maximum three year carry back period is based on strict calendar years. If a company has changed its accounting date within the last three years, an apportionment will be required.

Example Revisited
Let us now assume that Blaven Ltd changed its accounting date in 2019 and that the profits and losses described above arose instead in the following accounting periods:

Year ending 31st March 2018:	*Profit £20,000*
Year ending 31st March 2019:	*Profit £60,000*
Nine months ending 31st December 2019:	*Profit £30,000*
Year ending 31st December 2020:	*Loss £73,000*
Year ending 31st December 2021:	*Loss £25,000*

The loss arising in 2020 will be set off exactly as described before. However, the loss arising in 2021 can be carried back as far as 1st January 2018 (i.e. three years before the beginning of the loss-making accounting period).

This means that part of the profits for the year ending 31st March 2018 are now eligible for the losses arising in 2021 to be set off against. Blaven Ltd can therefore set £4,932 of those losses (£20,000 x 90/365) against the 2018 profits, leaving only £3,068 to be carried forward.

Large Companies

Now let's look at an example where the £2m limit does apply.

Example

Cuillin Ltd has made the following total profits and losses for the years ending 31st December. As before, the losses represent surplus trading losses remaining after set off against any other income or capital gains arising in the same period.

2018: Profit £8m
2019: Profit £3m
2020: Loss £7.3m
2021: Loss £2.5m

The loss arising in 2020 can be set off against the 2019 profits without limit. A further £2m can be carried back to 2018. The remaining £2.3m can only be carried forward.

The loss arising in 2021 needs to be carried back to 2020 first, but there are no profits available. It is then carried back to 2019. The company's profits for 2019 have been reduced to £1m due to the carry back of losses from 2020. Hence, £1m of the 2021 losses are carried back to 2019 and set off in that year. A further £1m (to reach the £2m maximum) may be carried back to 2018. The remaining £0.5m of the 2021 losses can only be carried forward. Together with the unused losses from 2020, this means a total of £2.8m is now carried forward.

5.4 MAKING A CLAIM

As usual, the extended loss carry back claim must be made within two years of the end of the loss-making accounting period.

Where the company is eligible to carry back no more than £200,000, after taking account of the existing relief available for a carry back up to twelve months, the claim can be made as a separate, stand alone claim. This is a useful facility that enables smaller companies to make claims before finalising their

Corporation Tax Return for the loss-making period (although I understand there have been a few problems in practice).

The £200,000 de minimis claim limit is based not on the actual claim, but the maximum claim the company might be eligible to make. Hence, the position has to be looked at on the basis that the company makes any capital allowances claims it is eligible to make and before surrendering any losses by way of group relief.

Example

Mayar Ltd makes a trading loss of £270,000 for the year ending 31st March 2022. This includes all the capital allowances the company is entitled to claim.

The company made a profit of £80,000 in the year ending 31st March 2021, so it only has £190,000 to claim under the additional, extended loss carry back rules.

Mayar Ltd is therefore able to make a stand-alone loss carry back claim.

Where the maximum potential claim exceeds £200,000, the claim must be made through the company's Corporation Tax Return for the loss-making period.

5.5 CLAIM CHOICES

Loss carry back claims are not compulsory. Where the company anticipates returning to profit in the near future, and expects those profits to exceed £50,000 a year, it may get more value from its trading losses by carrying them forward.

Example

Driesh Ltd made profits of £250,000 every year until the year ended 31st March 2021, when it made a loss of £200,000. It made a further loss of £100,000 in the year ending 31st March 2022, but anticipates breaking even in the year ending 31st March 2023. The company expects to return to an annual profit of £250,000 thereafter.

Scenario 1: *The company could carry back both its 2021 and 2022 losses, totalling £300,000 and get tax refunds totalling £57,000 (£300,000 x 19%).*

Scenario 2: *The company could carry forward both its 2021 and 2022 losses, and set £250,000 off against its profits for the year ending 31st March 2024, saving £62,500 (£250,000 x 25%) and a further £50,000 against its profits for the year ending 31st March 2025, saving £13,250 (£50,000 x 26.5%).*

The total saving of £75,750 is £18,750 more than under Scenario 1, but there is a huge cashflow disadvantage between the refund under Scenario 1 and savings which, in cash terms, are mostly realised on 1st January 2025 (£62,500), and partly not until 1st January 2026 (£13,250).

Scenario 3: *The company could carry forward its 2021 loss of £200,000, but carry back its 2022 loss of £100,000. This would provide a tax refund of £19,000 (£100,000 x 19%) in respect of the 2022 loss, plus a saving of £53,000 when the 2021 loss is set off against the profits for the year ending 31st March 2024 (£200,000 x 26.5%). The total saving would thus be £72,000.*

Scenario 4: *The company could carry back its 2021 loss of £200,000, but carry forward its 2022 loss of £100,000. This would provide a tax refund of £38,000 (£200,000 x 19%) in respect of the 2021 loss, plus a saving of £26,500 when the 2022 loss is set off against the profits for the year ending 31st March 2024 (£100,000 x 26.5%). The total saving would thus be £64,500.*

Scenario 1 provides the most certainty and the best cashflow. Scenario 2 will eventually provide the greatest savings but is dependent on uncertain forecasts about the future which may not be correct. The others are compromises.

Another important factor to bear in mind is that there will be another intermediate accounting period ending during the 2022 Financial Year before the company's marginal tax rate increases. If losses are carried forward but then simply used up against profits arising in this intermediate accounting period, there will be no additional tax saving while the company will still suffer a cashflow disadvantage. It's a difficult decision, although the two year period allowed for making the claim may prove helpful: but not if you really need that tax refund now!

Chapter 6

Salary versus Dividends

6.1 PROFIT EXTRACTION PRINCIPLES

A major issue faced by most company owner/directors is how to extract profits from their company tax efficiently. The changes in the Corporation Tax rate that we looked at in Chapter 2 mean this issue needs to be revisited to determine what the best strategy is at different marginal Corporation Tax rates.

We also need to deal with other important changes arising during 2022/23 and 2023/24:

- The rate of employee's Class 1 National Insurance on director's earnings up to the upper limit of £50,270 increases to 12.73% for 2022/23, but reduces back to its previous level of 12% for 2023/24
- The rate of employee's Class 1 National Insurance on director's earnings in excess of £50,270 increases to 2.73% for 2022/23, but reduces back to its previous level of 2% for 2023/24
- The rate of employer's Class 1 National Insurance on director's earnings increases to 14.53% for 2022/23, but reduces back to its previous level of 13.8% for 2023/24
- The primary threshold for National Insurance applying to director's earnings increases to £11,908 for 2022/23 and will increase again, to match the Income Tax personal allowance of £12,570, from 2023/24 onwards
- The rates of Income Tax payable on dividends increased with effect from 6th April 2022, and are now as follows:
 - Basic rate taxpayers 8.75%
 - Higher rate taxpayers 33.75%
 - Additional rate taxpayers 39.35%

The proposed Health and Social Care Levy, due to apply from 6th April 2023, has been scrapped.

In this chapter, I am going to provide a brief summary of the position for both 2022/23 and 2023/24, taking all these changes into account.

However, in practice, there are many additional factors to be considered, including other possible methods of profit extraction.

For a more detailed examination of this topic, see the Taxcafe.co.uk guides *'Salary versus Dividends'* or *'Tax Planning for Directors'* for general guidance; or *'Using a Property Company to Save Tax'* for issues of most relevance to property companies.

To simplify matters, in this guide, I will generally assume the owner/director has no interest or dividend income from other sources outside their own company. Interest and dividends from other sources may complicate matters, although they generally only make a small difference to the outcome, especially if the income from other sources is small. Annual interest income of no more than £500 will generally make no difference at all and can usually be ignored for the purposes of the guidance in this chapter. The impact of small amounts of dividend income is considered in Section 6.4.

I will also only consider twelve month company accounting periods and, as usual, the £50,000 and £250,000 profit limits referred to must be reduced if there are any associated companies (see Section 2.4).

I am also going to focus exclusively on payments to owner/directors. Salary payments to spouses, partners, and other members of the owner/director's family are often a good tax saving strategy but lie beyond the scope of this guide.

To extract profits from your company tax efficiently, you need to take account of:

a) Your own personal tax costs,
b) Any tax costs falling on the company, and
c) Any Corporation Tax relief available to the company

Factors (a) and (b) depend on your personal tax position for the tax year in which the payments are made to you; but factor (c) generally depends on the company's Corporation Tax position, and the rate of Corporation Tax, for the accounting period in which it makes those payments. All three factors are going through changes at present.

There are two main methods for extracting profits from your company: paying yourself a salary or bonus (i.e. employment income), or paying yourself dividends.

In the absence of any other options such as rent or interest (for which see the Taxcafe.co.uk guides mentioned above), dividends usually represent the most tax efficient method for extracting funds from your company; although it is generally worth paying yourself a small salary first.

6.2 SALARIES

Employment income is subject to three taxes:

i) Income Tax
ii) Employee's Class 1 National Insurance
iii) Employer's secondary Class 1 National Insurance

The rates for each of these taxes are set out in Appendix B. The combined cost of all three taxes in 2022/23 is quite prohibitive: 47.26% for a typical basic rate taxpayer; 57.26% for a typical higher rate taxpayer; more in some cases. There may also be student loan repayments and compulsory pension contributions to consider; although the latter are probably not relevant in the case of your own company.

Despite this, small salary payments can be very tax efficient, especially as these will generally provide Corporation Tax relief for the company.

Payments of wages, salaries or bonuses are deductible against the company's taxable profits for Corporation Tax purposes, as long as they are incurred for the benefit of the company's business. In the case of an owner/director, there will seldom be any doubt about this.

Tax Efficient Salaries

The best level of salary to pay yourself depends on a number of factors. The issue has been rendered more complex from 2020/21 to 2022/23 since, in a spectacular display of their utter inability to ever genuinely simplify the tax system, the Government has chosen to allow the primary and secondary National Insurance

thresholds to drift apart again, after having been aligned at the same level from 2017/18 to 2019/20. More recent changes have widened the gap between the thresholds considerably but 2023/24 will see some simplification again as the primary threshold is aligned with the personal allowance. About time too, in my opinion!

This Year (2022/23)

The secondary threshold is now much lower than the primary threshold, standing at £9,100 for 2022/23. Salaries up to this level can usually be paid free from both employer's and employee's National Insurance. Hence, with a Corporation Tax saving of between 19% and 26.5% available, such salaries will generally be tax efficient.

Director's salaries in excess of £9,100 in 2022/23 may be subject to employer's National Insurance at 14.53% on the excess, although there are a number of exceptions (as detailed below). Where employer's National Insurance is payable, it is more tax efficient overall to restrict the director's salary to the level of the secondary threshold (£9,100) when the director also intends to take sufficient dividends out of the company to push their total taxable income over £100,000.

In other cases, where either employer's National Insurance is not payable, or the director's total taxable income will not exceed £100,000, it will usually be worth increasing the salary to the level of the primary threshold (£11,908 for 2022/23).

A salary up to this level will usually be free from employee's National Insurance. Hence, where it is covered by the recipient's personal allowance, the payment of a further £2,808, to bring the director's salary up to a total of £11,908, will often remain tax efficient.

Where employer's National Insurance is due on this additional £2,808, it will cost £408 (£2,808 x 14.53%). However, for accounting periods ending before 1st April 2023, the additional payment will produce a Corporation Tax saving of £611 (£2,808 + £408 = £3,216 x 19% = £611); thus yielding an overall net saving of £203.

That saving will be greater where the company's accounting period ends after 31st March 2023 and the company has annual profits in excess of £50,000.

For example, the net additional saving produced by paying a salary of £11,908 instead of £9,100 to a director during 2022/23, but also during a twelve month company accounting period ending on 31st December 2023 will be:

- £203 where the company's profits are £50,000 or less
- Between £203 and £385 where the company's profits are between £50,000 and £53,216
- £385 where the company's profits are between £53,216 and £250,000
- Between £348 and £385 where the company's profits are between £250,000 and £253,216
- £348 where the company's profits are £253,216 or more

The profit levels here are before taking account of the additional £2,808 in salary and resultant employer's National Insurance arising of £408. The relevant Corporation Tax rates are as given in Appendix A.

(Whether you feel these net savings justify the additional admin involved is a matter of personal choice; and possibly also dependent on who does your payroll and how they calculate their charges!)

In most cases, it is not tax efficient to make salary payments in excess of the primary threshold since, unless one of the relevant exceptions applies, the excess will suffer a total National Insurance cost of 27.26% in 2022/23 (12.73% paid by the director and 14.53% paid by the company). This generally outweighs the Corporation Tax saving produced by the payment, although we will examine this issue further below.

Next Year (2023/24)

In future years, when the primary threshold has been aligned with the personal allowance (currently expected to remain at £12,570 each year until 2025/26, although this may change in view of current inflation rates), a slightly greater salary will be possible before any employee's National Insurance is suffered.

At current inflation rates, the secondary threshold would normally be expected to increase to an estimated £10,036 in 2023/24.

As in 2022/23, it will not be tax efficient to pay a salary in excess of the secondary threshold in 2023/24 where employer's National Insurance is payable on that excess and the director also intends to take sufficient dividends out of the company to push their total taxable income over £100,000.

In other cases, however, it will generally be worth paying a salary of £12,570 in 2023/24. Subject to the exceptions outlined below, this will attract employer's National Insurance of £350 (£12,570 – £10,036 = £2,534 x 13.8% = £350).

The company will then obtain Corporation Tax relief at somewhere between 19% and 26.5% on all of the salary plus the employer's National Insurance it suffers. The additional Corporation Tax saved by paying a salary of £12,570 instead of £10,036 will therefore be somewhere between:

£2,534 + £350 = £2,884 x 19% = £548; and
£2,534 + £350 = £2,884 x 26.5% = £764

Hence the net additional saving produced by increasing a director's salary from £10,036 to £12,570 in 2023/24 will be somewhere between £198 and £414.

Admittedly the secondary National Insurance threshold used here is an estimate. But, whatever that threshold turns out to be, it remains a fact that increasing a director's salary to the level of the personal allowance in 2023/24 will often be tax efficient where that director has no other taxable income from outside the company.

Summary so Far

In most cases, where the director has no other taxable income from outside the company, the most tax efficient salary level is £11,908 in 2022/23 and is expected to be £12,570 in 2023/24.

However, where the director's salary will be subject to employer's National Insurance and the director also intends to take sufficient dividends out of the company to give them total taxable income in excess of £100,000, their salary should be restricted to the level

154

of the secondary threshold (£9,100 in 2022/23, estimated at £10,036 for 2023/24).

Exceptions

Even in the current 2022/23 tax year, there are a number of exceptions, where it may sometimes be slightly more tax efficient to increase the salary payment to the level of the personal allowance (£12,570). These include cases where:

- The company's marginal Corporation Tax rate for the relevant accounting period is at least 25% (see Appendix A)
- The recipient is over state pension age (no employee's National Insurance will be due)
- The recipient is aged under 21 (no employer's National Insurance will be due on payments up to the higher rate tax threshold)
- The recipient is an apprentice aged under 25 (no employer's National Insurance will be due on payments up to the higher rate tax threshold)
- The employment allowance is available (see below)

Any other taxable income received by the director needs to be taken into account when determining their optimal salary level. For those over state pension age, this will usually include their state pension. We will take a closer look at directors over state pension age in Section 6.3.

As far as the other potential exceptions noted above are concerned, a salary of £12,570 may be more beneficial where the director has no other taxable income.

However, this does not apply where the director also plans to take sufficient dividends to make them a higher rate taxpayer and either:

a) The company's Corporation Tax rate for the accounting period is 19%, or
b) A higher marginal Corporation Tax rate applies but employer's National Insurance is payable

Admittedly the position under (a) is pretty borderline in most cases, as taking the higher salary costs just £1 extra overall under

these circumstances: provided the director's total taxable income does not go over £100,000.

The position under (a) changes if the payment is made in an accounting period straddling 1st April 2023 and the company has profits in excess of £50,000 (and hence a higher marginal Corporation Tax rate). Taking the higher salary will then produce an overall saving as long as the director's total taxable income does not go over £100,000 and employer's National Insurance is not payable.

For example, a salary of £12,570 paid to a higher rate taxpayer director during 2022/23 but also during a twelve month accounting period ending 31st December 2023 will save £36 overall compared to a salary of £11,908 where:

- The company's profits for the period are between £50,000 and £250,000
- The director has no taxable income from outside the company
- The director does not also take more than £87,430 in dividends
- Employer's National Insurance is not payable on the salary (due to one of the exceptions noted above)

If a director under state pension age is planning to take sufficient dividends to push their total taxable income over £100,000, it will never be worth them taking a salary of more than £11,908 in 2022/23. Furthermore, as discussed above, where employer's National Insurance is payable, a salary of just £9,100 is most tax efficient.

All in all, while there are a number of exceptions that might make a salary of £12,570 slightly more tax efficient in 2022/23, for directors under state pension age, the potential savings are too small to worry about and are wiped out altogether if total taxable income exceeds £100,000.

Admin and Other Sundry Points

Salaries and other payments to employees (including directors) are subject to strict reporting requirements under the PAYE regulations. Furthermore, with the exception of directors, National Insurance liabilities are based on 'pay periods' rather than being an annual charge. This means, for non-directors, salary payments may need to be made in regular instalments rather than a single

lump sum, in order to avoid giving rise to additional National Insurance costs. For further details on PAYE obligations, and National Insurance thresholds for pay periods, see the Taxcafe.co.uk guide *'Putting it Through the Company'*.

The Employment Allowance

Most employers are entitled to exemption from a total of up to £5,000 of employer's Class 1 National Insurance each tax year (£4,000 prior to 2022/23). This is subject to two exclusions:

i) Large businesses with total employer's National Insurance costs of £100,000 or more, and
ii) Companies where a single owner/director is the only employee

The second exclusion will affect many small companies with a single owner/director. Furthermore, HMRC incorrectly interprets this rule as meaning at least one other person must be paid in excess of the secondary National Insurance threshold whereas, in fact, what the legislation actually says is there simply needs to be at least one other employee (on any level of pay).

Nonetheless, to be on the safe side, in order to ensure the employment allowance is available where you are a single owner/director, it may be wise to make sure another person receives more salary than the secondary National Insurance threshold for the relevant pay period (for 2022/23, this means paying them at least £759 per month, or £176 per week).

Where the employment allowance is available, and has not already been used up on payments to other employees, it may be worth increasing your salary for 2022/23 to a level that uses up your personal allowance (subject to the points made above).

In other cases, where you expect to have total taxable income in excess of £100,000 for the tax year, it becomes worth increasing your salary up to the level of the primary threshold (£11,908 for 2022/23, £12,570 for 2023/24) where the employment allowance is available to cover the employer's National Insurance on your increased salary.

In 2022/23, a director suffers employee's National Insurance at 12.73% on any payment in excess of the primary threshold of

£11,908 but, where the employment allowance is available, the company will be exempt from employer's National Insurance. Furthermore, the company will be entitled to Corporation Tax relief on the full amount paid: thus providing a net saving of 6.27%, even at a Corporation Tax rate of 19%.

Where a couple, or any two individuals, own a company together, they can each be paid salaries up to the personal allowance in 2022/23 without any employer's National Insurance arising, as long as the company either has no other employees, or has at least £1,008 of its employment allowance still available.

The same result can be achieved where one person is the sole owner of the company, but simply employs another family member in the business (see above regarding pay periods for non-directors).

How Far Does the Employment Allowance Go?

As we will see below, there are some exceptional cases where a salary in excess of the personal allowance will be tax efficient. Some of these depend on the employment allowance being available. The maximum director's salaries that can be covered by the employment allowance will vary from company to company, but two of the most common scenarios, at 2022/23 rates, are:

- Single director with one other employee earning £759 per month (just over the secondary National Insurance threshold): £43,504
- Two directors with no other employees: £26,306 each

These maximum salaries would be the same where the company has other employees, but those employees' salaries are exempt from employer's National Insurance (e.g. employees aged under 21 and earning less than £50,270).

Salaries in Excess of the Personal Allowance

Salary payments in excess of the personal allowance are not usually tax efficient, but there are some exceptions to this, including cases where the owner/director is over state pension age and the employment allowance is also available.

We will look at owner/directors over state pension age in Section 6.3. For younger owner/directors, other exceptions to be aware of include those set out below. Dividends at least equal to the director's available dividend allowance (see Section 6.4) should also generally be taken where these exceptions apply.

Owner/Directors Earning a Salary of at least £50,270 from Another Job

Even when the employment allowance is not available, additional salary may sometimes become more tax efficient when the company's marginal Corporation Tax rate is at least 24.6% for payments in 2022/23, or 24.1% for payments in 2023/24. See Appendix A for the applicable marginal rates.

As usual, this does not apply where the director's total taxable income will be more than £100,000.

Where the employment allowance is available, additional salary becomes more tax efficient whatever the company's Corporation Tax rate is: until the allowance has been exhausted. Further salary payments beyond that should only be made where they meet the criteria set out above.

Big Earners

For the very largest companies paying Corporation Tax at 25% in future periods, where the owner/director wishes to withdraw net, after tax, income of at least £248,000 in an accounting period commencing after 31st March 2023, it will become more tax efficient to take a dividend equal to the director's available dividend allowance (see Section 6.4) and the rest of their income as salary.

This phenomenon will start to arise in earlier accounting periods, commencing after 31st October 2022 but, where the accounting period straddles 1st April 2023, the amount of income the director wishes to extract has to be greater.

Such large salaries may cease to be tax efficient if the salary, together with the related employer's National Insurance, reduces the company's profit below £50,000.

6.3 DIRECTORS OVER STATE PENSION AGE

Owner/directors over state pension age are not subject to employee's National Insurance. This means higher salary levels than we saw in Section 6.2 will often be tax efficient for older owner/directors.

To begin with, a salary equal to the greater of the amount of the secondary National Insurance threshold or the director's remaining available personal allowance after accounting for other income from outside the company will always be tax efficient.

Beyond that, the position is dependent on the company's marginal Corporation Tax rate and on whether the employment allowance is available.

Without Employment Allowance: 2022/23

For basic rate taxpayers, a salary is more tax efficient where the company's marginal Corporation Tax rate is at least 23.5%. For companies with annual profits between £50,000 and £250,000, this means accounting periods ending on 30th November 2023 or later; for companies with annual profits over £250,000, this means accounting periods ending on 31st December 2023 or later.

For higher rate taxpayers, a salary is more tax efficient where the company's marginal Corporation Tax rate is at least 21%, although the position may change where the director's total taxable income for the year exceeds £100,000. Nonetheless, it's worth looking into for companies with annual profits in excess of £50,000 and an accounting period ending on 31st July 2023 or later.

Without Employment Allowance: 2023/24

For basic rate taxpayers, a salary is more tax efficient where the company's marginal Corporation Tax rate is at least 23%. For companies with annual profits between £50,000 and £250,000, this means accounting periods ending on 31st October 2023 or later; for companies with annual profits over £250,000, this means accounting periods ending on 30th November 2023 or later.

For higher rate taxpayers, a salary is more tax efficient where the company's marginal Corporation Tax rate is over 20.42%, although the position may change where the director's total

taxable income for the year exceeds £100,000. Nonetheless, it's worth looking into for companies with annual profits in excess of £50,000 and an accounting period ending on 30th June 2023 or later.

With Employment Allowance

Any salary paid to an owner/director over state pension age that is covered by the employment allowance is more tax efficient than dividends, except as noted below. See Section 6.2 for some guidance on salary levels that might be covered.

Salaries versus the Dividend Allowance for Older Directors

Dividends covered by the dividend allowance (Section 6.4) should generally be paid before any salary not covered by the personal allowance.

However, a salary paid to a basic rate taxpayer is better even than dividends covered by the dividend allowance when the company's marginal Corporation Tax rate exceeds 20% and there is no National Insurance cost. In both 2022/23 and 2023/24, this arises for owner/directors over state pension age when:

- A salary up to the secondary National Insurance threshold (£9,100 in 2022/23, estimated at £10,036 for 2023/24) is paid, or
- Any level of salary covered by the employment allowance (see Section 6.2) is paid

AND

- The company has annual profits in excess of £50,000, and
- The accounting period ends on 31st May 2023 or later

Naturally, even in these cases, there is nothing to stop the director also taking dividends covered by the dividend allowance; I am simply saying that these tax-efficient salaries should be prioritised first.

6.4 DIVIDENDS

Subject to the dividend allowance described below, dividends are subject to Income Tax at the following rates from 6th April 2022:

Basic rate taxpayers:	8.75%
Higher rate taxpayers:	33.75%
Additional rate taxpayers:	39.35%

The Dividend Allowance

Each individual has an annual dividend allowance (currently £2,000) that reduces the rate of Income Tax on the first part of their dividend income (up to the amount of the allowance) to nil. Dividends falling within the allowance are still included as taxable income for other purposes, however.

An individual's personal allowance is used first before the dividend allowance is considered. Or, put another way, dividends covered by an individual's personal allowance do not use up their dividend allowance.

Subject to this, the dividend allowance is used against all dividend income received during the tax year from any source. For example, if an owner/director has at least £12,570 of non-dividend income, plus £200 of dividend income from stock market investments, they will only have £1,800 of their dividend allowance left to cover dividends from their own company.

Assuming the company has sufficient distributable profits (see below) it makes sense for owner/directors to pay themselves dividends at least equal to their available dividend allowance each tax year, as these are tax free.

Other Considerations

Dividends represent a distribution of a company's after-tax profits and no deduction is therefore allowed for Corporation Tax purposes.

No business justification is required for dividends, although company law does require distributable profits to be available. Hence, having your spouse, partner, or another adult family member as a shareholder in your company may be a useful tax-planning measure. (Dividends paid to minor children from their parent's company will be taxed in the parent's hands.)

6.5 SUMMARY

The 'salary versus dividends' question seems to grow ever more complex and is now dependent on many factors, including:

- The owner/director's personal tax position
- Whether the owner/director has another job
- The owner/director's age
- Whether the employment allowance is available
- The company's annual profit level
- The dates the company's accounting period begins and ends

In this chapter, I have summarised the main factors to consider and we have seen many exceptions, quirks and nuances that need to be taken into account. Nonetheless, in most cases, the position can be summarised as follows.

1. Take Your Optimum Salary

First, take the most tax efficient salary applying in your case. This will always be at least equal to the secondary National Insurance threshold (£9,100 for 2022/23, estimated at £10,036 for 2023/24).

It's generally worth increasing your salary to the primary National Insurance threshold (£11,908 for 2022/23, £12,570 for 2023/24) where the extra salary is still covered by your personal allowance (i.e. you have no more than £662 of taxable income from outside the company in 2022/23, or no income at all from outside the company in 2023/24). This is not generally the case where you expect to have total taxable income in excess of £100,000 for the year, however.

It may also be worth increasing your salary to the primary National Insurance threshold, even when you have more income from outside the company, but your company's marginal Corporation Tax rate is at least 23.5% (for payments in 2022/23) or 23% (for payments in 2023/24): although this is not the case if you will be a higher rate taxpayer for the year.

Where certain exceptions, as set out in Section 6.2, apply, it may sometimes be worth increasing your salary further in 2022/23, provided it is still covered by your personal allowance. However the benefit for directors under state pension age is marginal at best and only applies under restricted circumstances.

Greater salaries, above the personal allowance may be beneficial in some cases for:

- Directors over state pension age (Section 6.3)
- Directors with an existing salary of at least £50,270 from another job (see Section 6.2)
- Directors of large companies wishing to extract more than £248,000 in net, after tax income (see Section 6.2)

2. Use Your Dividend Allowance

Whatever your optimal salary may be, it will make sense to also take any dividends that are covered by your dividend allowance (see Section 6.4).

3. Take More Dividends

If you still need to extract any further sums from the company, take them as dividends. However, it's worth bearing in mind that taxable income over £100,000 comes at a heavy price. For further guidance in these circumstances, see the Taxcafe.co.uk guides *'Tax Planning for Directors'* or *'Salary versus Dividends'*.

6.6 DEFERRING PAYMENTS

Is it worth deferring payments to yourself in order to benefit from greater Corporation Tax savings in the future?

Firstly, the question can only arise for owner/directors whose company makes annual profits in excess of £50,000.

Secondly, deferring dividend payments will not result in any Corporation Tax savings (and, as a minimum, you should try to ensure you utilise your dividend allowance each tax year).

As far as salary is concerned, in the vast majority of cases, it will not be worth deferring a payment to save, at most, an extra 7.5% in Corporation Tax, if you will suffer a higher rate of Income Tax as a result.

Some salary payments should not generally be deferred as they produce an overall net tax saving. Broadly (subject to the more detailed points in Section 6.2), these are salary payments that are

covered by your personal allowance (£12,570) and which either do not suffer any National Insurance, or which will suffer only one type of National Insurance (employer's or employee's, but not both). To this list we can add salary payments to basic rate taxpayer directors over state pension age that are covered by either the employment allowance or the secondary threshold, where the company's marginal Corporation Tax rate is already over 20%.

However, it may be worth deferring these salary payments to a later accounting period, provided:

i) They will still fall into the same tax year for Income Tax purposes,
ii) Deferring the payment means the cost will be accounted for in the later accounting period and will not need to be accrued in the earlier period, and
iii) Suitable salary payments can be made again in the next tax year and the cost will again be accounted for in the same accounting period as the deferred payments

Example
Ollie's company has a 31ˢᵗ December accounting date and makes profits of around £200,000 each year. He has no other sources of income and usually pays himself a salary equal to the National Insurance primary threshold in a single lump sum each December.

However, he delays his salary payment of £11,908 from December 2022 to March 2023, so that it falls into his company accounting period ending 31ˢᵗ December 2023, thus providing Corporation Tax relief on the salary and related employer's National Insurance cost of £408 (£12,316 in total) at 24.651% instead of 19%, saving the company an extra £696.

He also delays his salary payment of £12,570 from December 2023 to March 2024, so that it falls into his company accounting period ending 31ˢᵗ December 2024, thus providing Corporation Tax relief on the salary and related employer's National Insurance cost of £350 (£12,920 in total) at 26.5% instead of 24.651%, saving the company a further £239.

In December 2024, he takes his salary of £12,570 as normal and this is covered by his personal allowance and primary National Insurance threshold for 2024/25. He is then able to claim Corporation Tax relief on two years' worth of tax-free salaries in his company's accounting

period ending 31st December 2024. He feels he deserves his salaries as he's saved the company an extra £935 (£696 + £239) over the last couple of years.

Greater Corporation Tax savings may be available by deferring other salary payments, and it may sometimes be possible to defer these to a later tax year. However, it will be vital to consider your own Income Tax position first: marginal Income Tax rates vary a lot more than marginal Corporation Tax rates.

Appendix A

Marginal Corporation Tax Rates 2018 to 2024

Year Ending:	Small Profits Rate	Marginal Rate	Main Rate
31-Mar-2018 to 31-Mar-2023	n/a	n/a	19.000%
30-Apr-2023	19.000%	19.616%	19.493%
31-May-2023	19.000%	20.253%	20.003%
30-Jun-2023	19.000%	20.870%	20.496%
31-Jul-2023	19.000%	21.507%	21.005%
31-Aug-2023	19.000%	22.144%	21.515%
30-Sep-2023	19.000%	22.760%	22.008%
31-Oct-2023	19.000%	23.397%	22.518%
30-Nov-2023	19.000%	24.014%	23.011%
31-Dec-2023	19.000%	24.651%	23.521%
31-Jan-2024	19.000%	25.288%	24.030%
29-Feb-2024	19.000%	25.865%	24.492%
31-Mar-2024	19.000%	26.500%	25.000%

Due to the 'leap year quirk' referred to in Section 2.7, for twelve month accounting periods ending on any date between 1st April 2023 and 28th February 2024, the small profits rate will apply to profits up to £49,863; the marginal rate will apply to profits between £49,863 and £249,317; and the main rate will apply to profits over £249,317.

For twelve month accounting periods ending on any date from 29th February 2024 onwards, the small profits rate will apply to profits up to £50,000; the marginal rate will apply to profits between £50,000 and £250,000; and the main rate will apply to profits over £250,000.

These limits are, of course, subject to the rules for associated companies (see Section 2.4).

Appendix B

UK Tax Rates and Allowances: 2021/22 to 2023/24

	Rates	2021/22 £	2022/23 £	2023/24 £
Income Tax (1)				
Personal allowance		12,570	12,570	12,570
Basic rate band	20%	37,700	37,700	37,700
Higher rate/Threshold	40%	50,270	50,270	50,270
Personal allowance withdrawal				
Effective rate/From	60%	100,000	100,000	100,000
To		125,140	125,140	125,140
Additional rate	45%	150,000	150,000	150,000
Starting rate band (2)	0%	5,000	5,000	5,000
Personal savings allowance (3)		1,000	1,000	1,000
Dividend allowance		2,000	2,000	2,000
Marriage allowance (4)		1,260	1,260	1,260
National Insurance				
Primary Threshold		9,568	11,908 (5)	12,570
Rate: Directors (Class 1)		12%	12.73%	12%
Self-Employed (Class 4)		9%	9.73%	9%
Upper earnings limit (UEL)		50,270	50,270	50,270
Additional rate above UEL		2%	2.73%	2%
Secondary Threshold (6)		8,840	9,100	10,036
Rate: Employers		13.8%	14.53%	13.8%
Class 2 per week		3.05	3.15	3.45 (6)
Class 2 threshold (7)		6,515	11,908	12,570

Notes
1. Different rates and thresholds apply to Scottish taxpayers (except on interest, savings income, and dividends)
2. Applies to interest and savings income only
3. Halved for higher rate taxpayers; not available to additional rate taxpayers
4. Available where neither spouse/civil partner pays higher rate tax
5. Threshold applying to self-employed taxpayers and company directors
6. Estimated, based on inflation per the CPI at 10%
7. From 2022/23, Class 2 only payable where profits exceed primary threshold
8. Rates and thresholds for 2023/24 are forecasts, based on our current understanding, but may be subject to change

Appendix C

Connected Persons

The definition of 'connected persons' differs slightly from one area of UK tax law to another. The definition generally applying for most Corporation Tax purposes is set out below. Note, however, that some of the connected persons listed below do not count as associates for the purpose of the associated company rules (see Section 2.5).

An individual's connected persons include the following:

i) Their husband, wife or civil partner
ii) The following relatives:
 o Mother, father or remoter ancestor
 o Son, daughter or remoter descendant
 o Brother or sister
iii) Relatives under (ii) above of the individual's spouse or civil partner
iv) Spouses or civil partners of the individual's relatives under (ii) above
v) Spouses or civil partners of an individual under (iii) above
vi) The individual's business partners and their:
 o Spouses or civil partners
 o Relatives (as defined under (ii) above)
vii) Trusts where the individual is:
 o The settlor (the person who set up the trust or transferred property, other assets, or funds into it), or
 o A person 'connected' (as defined in this appendix) with the settlor
viii)Companies under the control of the individual, either alone, or together with persons under (i) to (vii) above
ix) Companies under the control of the individual acting together with one or more other persons

Lightning Source UK Ltd.
Milton Keynes UK
UKHW022223251122
412825UK00008B/406